RADIANT

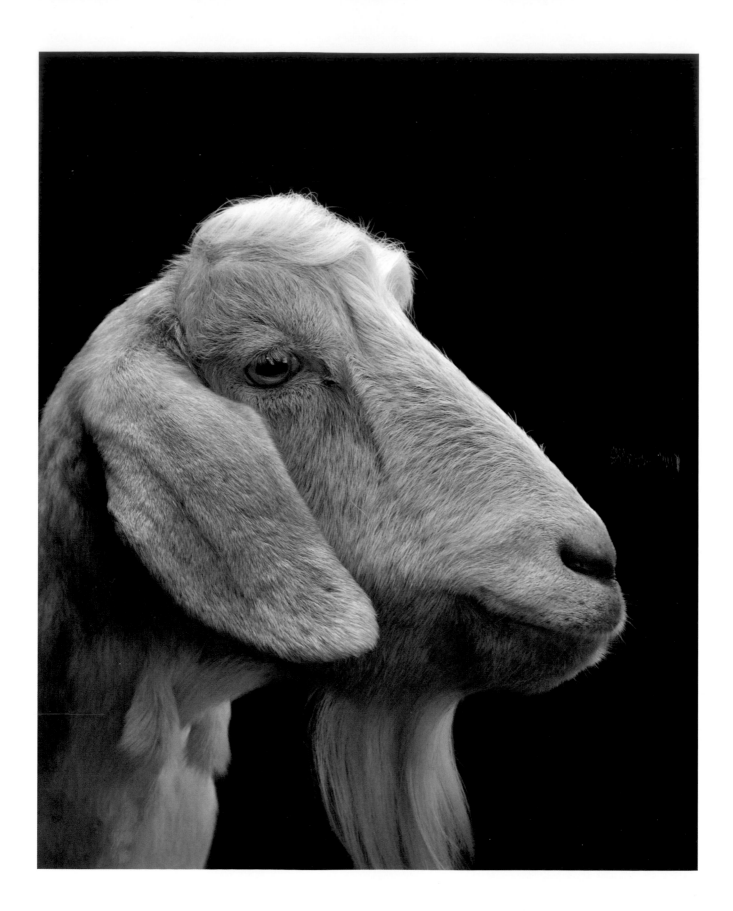

RADIANT

farm animals up close and personal

photographs by

TRAER SCOTT

PRINCETON ARCHITECTURAL PRESS · NEW YORK

To Agatha.
May you and your generation continue to
work toward making our world a place where all living
beings are treated with respect and dignity.

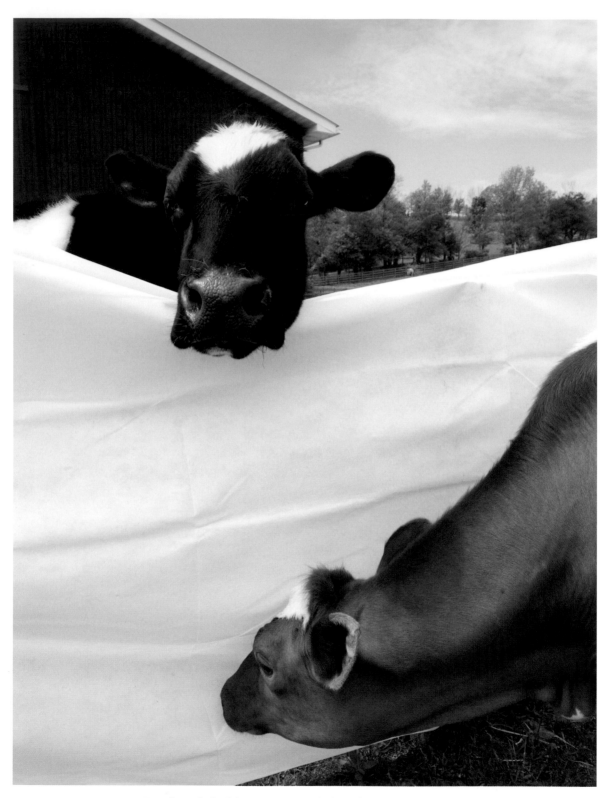

Cows are curious about the backdrop we're trying to hang for photo shoots at Farm Sanctuary.

INTRODUCTION

When I first began this project, I did an internet search for the name of a particular breed of cow along with the word *personality*. Lots of results for the breed came back, but below each result was this: Missing: ~~personality~~. These two tiny little words completely summed up my inspiration for making *Radiant: Farm Animals Up Close and Personal*. Now in all fairness, you CAN find the word *personality* used online in reference to cows, but words that are much more common are *production*, *characteristics*, and *output*, words that could easily be describing a machine. Livestock, by definition, are living machines that produce meat, milk, and other products.

It's impossible to talk about farm animals without having a discussion about what we eat, and factory farming is the elephant (or in this instance, cow) in the room. However, *Radiant* does not presuppose or demand that the reader is a vegetarian or vegan, either current or aspiring. These are simply portraits of creatures who are often overlooked in the scope of the expression "I love animals" and generally viewed as numbers rather than individuals. They may not be as outwardly emotive as dogs, as cuddly as cats, or as human as, well, humans, but any farmer can tell you that they have just as much personality, even if they're a little less portable and perhaps a mite stinkier.

Making these portraits was sublime. I got to meet cows, ducks, pigs, chickens, donkeys, and others in ideal settings with people they trust and, in many cases, love. I learned a lot about them. Although you're not supposed to have favorites, cows are my favorite. They are enormous (Tucker from Catskill Animal Sanctuary stood six and a half feet at the shoulder!) and yet such gentle, peaceful animals. They are social, they love the company of other cows, and they are often fascinated (if not frightened) by other species like dogs and goats. Cows' emotional cues are subtle; to people, these bovine giants often seem detached or lost in their own world, but they are watchful and curious and are quietly taking in everything around them: smells, sounds, movement, and mood. They form strong bonds with people who are kind and attentive to them.

At Catskill Animal Sanctuary I got the special treat of being escorted by founder Kathy Stevens. Several things were particularly remarkable about photographing with Kathy: her exceptional knowledge about every single one of the hundreds of animals in residence there and the fact that just about every animal transformed in her presence. Cows that wouldn't even look at me came running over once Kathy was by my side. Pigs who gave me a suspicious side eye, grunting with disapproval as I entered their yards, would immediately flop belly up for Kathy. Unlike dogs and other domesticated animals that are bred as pets, farm animals are not programmed to love us. To win the affection and trust of a farm animal, you must be patient, calm, and consistent.

The portrayal of pigs in popular culture is vast and takes many forms, but from *Charlotte's Web* to *Babe* to "The Three Little Pigs," one factor is always constant: intelligence. Fans of the animated British show *Shaun the Sheep* may remember pigs being portrayed as the ultimate eternal frat boys: macho, troublemaking, and clever. There is some truth in this characterization. Pigs are supersmart, and they're willful. A full-grown pig can weigh more than five hundred pounds and has enormous, sharp teeth. You don't want to mess with a big pig. Many pigs remind me of huge, brainy, food-obsessed toddlers who live every

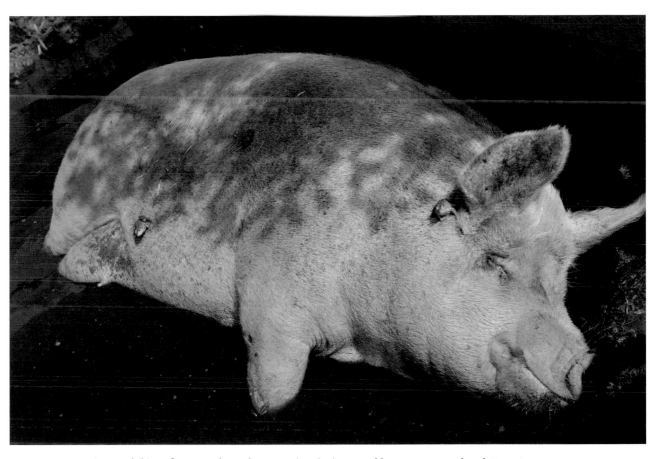

Tiny amphibious frogs sun themselves on a pig enjoying a muddy snooze at Woodstock Farm Sanctuary.

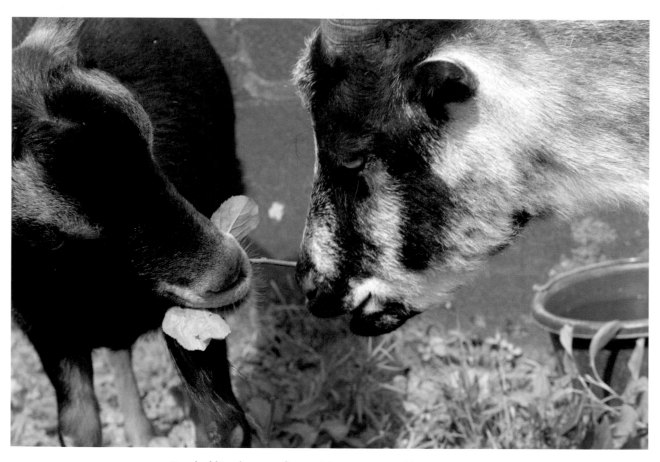

Goat buddies play tug-of-war with some greens at Farm Sanctuary.

glorious second of life to the fullest and aren't interested in wasting a single moment following your rules. They love getting dirty, sleep when they want to sleep, root around in everything with great vigor, and always, always want to eat. Like most other mammals, pigs are extremely social and playful. They love the company of other pigs but often also form strong bonds with different species, including cows, dogs, and humans. Many a pig that I met would immediately flop down for a belly rub or back massage, and when a pig shows affection like this, you know they really mean it because they're not particularly concerned with impressing us.

Turkeys are surprisingly charming and strikingly beautiful. They are quirky and funny and social. I watched Henri of Winslow Farm Animal Sanctuary for hours, strutting around with his feathers out in a beautiful display, jutting his beak and colorful, jiggly waddle out eccentrically while he gobbled and made a fantastic thumping bass drum noise in his chest to punctuate every expression. Henri loves hanging out with the chickens. A group of female turkeys at Farm Sanctuary was curious yet serious, oddly hilarious, checking out my camera and me with close scrutiny, beating paths around me in the dirt and, upon ultimately deciding that I was not a threat, settling down to stare at me like sentinels.

Chester, the Narragansett Heritage turkey at West Place Animal Sanctuary, prefers the company of people to animals. I was concerned that I wouldn't be able to get close to him or that he wouldn't have his feathers out, but he actually hangs out near the front so he can greet people. He is so affectionate that he actually allows some human favorites to hug him. Although decidedly unsure about the physical affection, when a staff or volunteer crouches down in front of him, he will waddle into their embrace and let them very lightly wrap their arms around him. Owner Wendy Taylor says Chester loves to literally be in the middle of human conversations. He likes to stand in between chatting people, and when one of them laughs, he gobbles in response.

One of the most peaceful moments I had in the many months of making *Radiant* was at Farm Sanctuary. We were hanging out with the

chickens, trying to lure them onto my backdrop, which is not the easiest of tasks. Chickens will follow the food, but like most farm animals, they're wary of new things. The staff member assisting me went to get some more feed, and while he was gone, I just lay down in the grass, surrounded by chickens. Quietly, they went about being chickens, cooing and gently pecking around me. It was the most soothing sound I have ever heard, and looking up at a clear summer sky through leafy green trees while a hum of peaceful life encircled me was mesmerizing.

Donkeys, with their big, doleful eyes and long, comical ears, are arguably among the cutest animals on the planet (watch out, sea otters). Years ago, when I was shooting my book *Wild Horses*, I stayed on a mustang reserve in California that was also home to rescued donkeys. Many of them were free-range and just wandered around the property. One was always near the front of the farm and would greet people when they came in. I believe his name was Jasper. Jasper followed me around like a dog for several days and would beg for carrots. He waited outside my cabin in the morning, and I would wake up to his braying right outside my window. I think he wanted company. Most of the sanctuary donkeys I met for *Radiant* came from situations of abuse or neglect and were less outgoing with strangers than Jasper, but they are all so gentle and serene. They are also very loyal and form deep friendships with other donkeys and humans. The donkeys are my six-year-old daughter's favorite animal on the farms because she says they snuggle—and they kind of do. Putting your arm around a donkey and feeling him soften and then gently lean into you is life-affirming.

Fortunately all of the animals in this book will live healthy, presumably long lives outdoors in fresh air and will have the added benefit of never ending up on someone's plate. They are all either residents of animal sanctuaries, companion animals, or inhabitants of hobby farms. There are no unhappy endings in this book; however, the farm animals in every sanctuary in the world combined represent a minuscule fraction of the nine billion animals raised for human consumption in the United States every year.

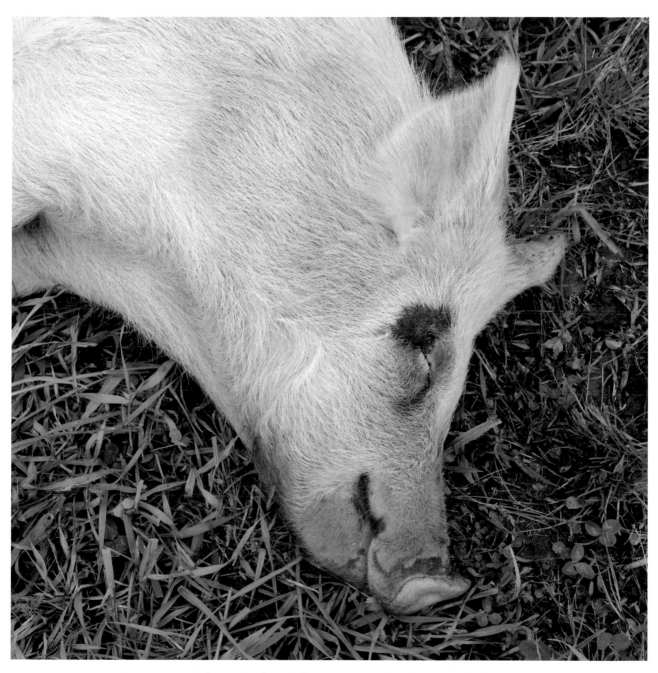

A happy pig relaxes in the green grass at Farm Sanctuary.

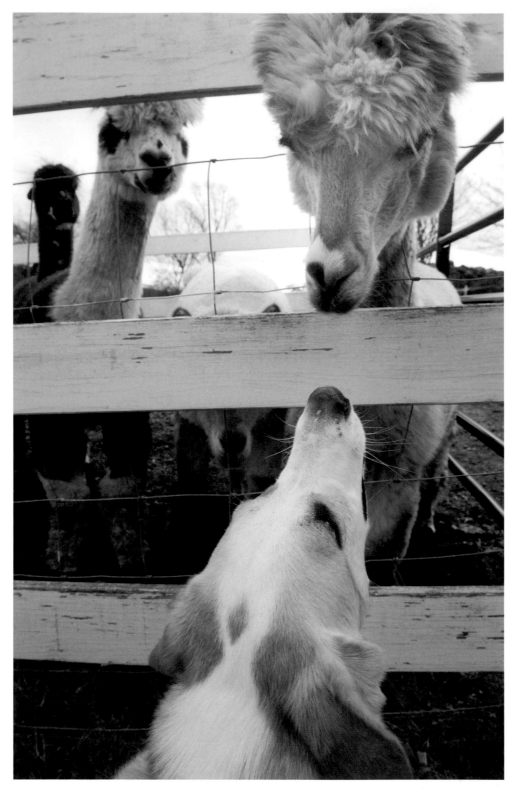

My dog Pip meets his blonde Alpaca doppelgänger at West Place Animal Sanctuary.

Since our planet is not getting any bigger, this is simply an unsustainable number. Not long ago, cows and pigs and chickens and sheep really did live on family farms, graze in pastures, and peck around in outdoor coops just like the misleading labels on many modern products will have you believe. But since the proliferation of industrial farming or "factory farming" in the 1960s, we have quietly ushered in a very different and unspeakably cruel reality for the majority of farm animals. The sole mission of a factory farm is to maximize output while minimizing cost in order to make a large profit and supply the ever-growing demand for cheap meat needed to feed an exploding population. The animals, the environment, and the consumer ultimately pay the price for the high profit margin and relentless output of factory farms.

Animals in factory farms are kept in extreme confinement their entire lives and are subjected to mutilation and torture from birth. Most factory farm animals are denied even the most basic humane comforts such as fresh air, healthy food, and space to turn around. With filthy, cramped conditions being the norm, disease spreads rapidly. Animals are fed antibiotics to keep them alive and make them grow faster. Many of these drugs end up being consumed by all those who eat the animals.

As bad as factory farming is for animals, it's possibly even worse for the environment. Industrial farming consumes a disproportionate amount of natural resources such as water, land, and fossil fuels in relation to the amount of food it produces. It is estimated that industrial agriculture sucks up a staggering 70 percent of the world's freshwater supplies. Producing just one pound of beef takes an estimated 1,581 gallons of water, which is roughly as much as the average American uses in one hundred showers.[1]

The staggering amount of waste produced by animals on industrial farms is one of the world's leading causes of pollution. In the United States alone, animals raised on factory farms generate more than one million tons of manure *per day*—three times the amount generated by the country's human population.[2] In 2010 the United Nations urged the world to eat less meat, reporting that "cattle-rearing generates more

global warming greenhouse gases, as measured in CO2 equivalent, than transportation."[2] This means simply that beef production is causing more damage to the planet than all of the cars, trucks, trains, airplanes, and buses combined.

Despite the overwhelming impact of factory farming, it is simply unrealistic to expect all of the world's 7.5 billion people to completely stop eating meat and eggs, so what is the answer? It's pretty simple, actually: small, absorbable changes. I believe that everyone wants to make compassionate and responsible choices when informed, but often implementing those choices means overhauling your routine, your cooking habits, your grocery list, even your social interactions. It's much easier to keep things status quo than it is to make a big change overnight. So if you're not up for a big change, make a series of small ones.

A great rule of thumb is: if it isn't from a farm you would like to visit with your kids, you probably shouldn't buy it. If you're buying meat sitting in shrink-wrapped Styrofoam in the meat aisle at a chain grocery store, chances are it's from a factory farm. If you're eating fast food or at chain restaurants, the meat is almost certainly from a factory farm. It might be cheaper, but the cost to your health, the planet, and the animals in production is immense.

If all of us just aimed our sights at less meat, more local choices, and more vegetables, the result would be revolutionary. Maybe vegetarianism isn't for you, but we can all still make better choices. Ultimately, being a healthy omnivore means eating more vegetables, fruits, grains, beans, and nuts—and being a conscious consumer means knowing where your food comes from.

1. "Factory Farming and the Envirmonment," Farm Sanctuary, https://www .farmsanctuary.org/learn/factory-farming/factory-farming-and-the-environment/.
2. Ibid.
3. "Rearing cattle produces more greenhouse gases than driving cars, UN report warns," *UN News,* November 29, 2006, https://news.un.org/en/story/2006/11/201222-rearing -cattle-produces-more-greenhouse-gases-driving-cars-un-report-warns.

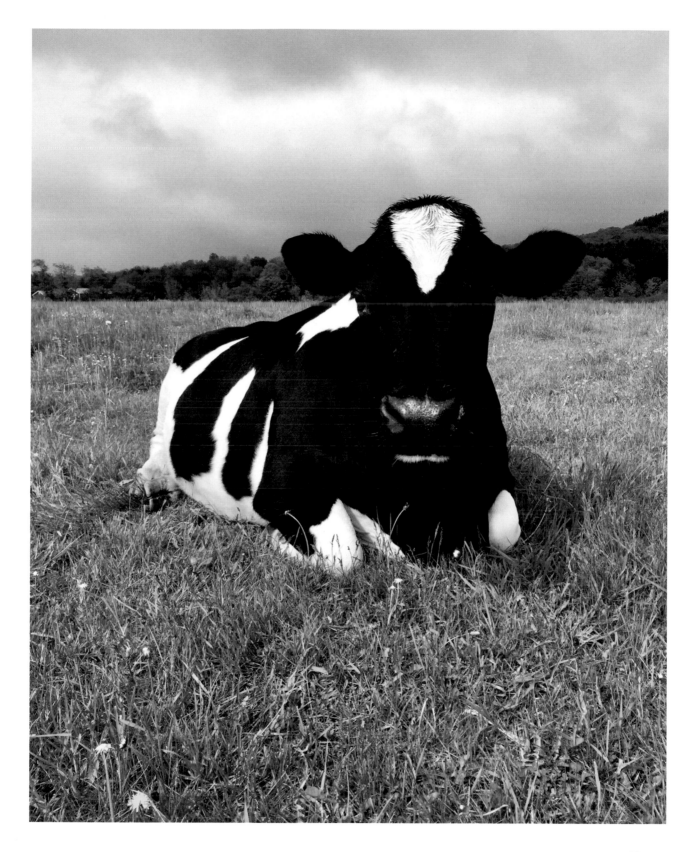

THE ANIMALS

WYATT

MILKING DEVON COW

...

The American Milking Devon is a critically rare livestock breed that originated in England but is now found only in the United States. Devons are calm, intelligent, and curious, which made them highly effective oxen. Pilgrims first brought this breed of cattle with them to New England as early as 1623 for beef, milk, and draft work, but farming trends gradually replaced them with other breeds over the next several centuries. The Devon faced a near extinction in the mid-twentieth century, but bloodlines were kept alive by a group of dedicated breeders. It is now estimated that about 1,500 Milking Devons live in the United States.

Wyatt is twenty-five years old, a ripe old age for a cow. A sweet and gentle old man, he greatly enjoys the company of two companion cows, one of whom is another Milking Devon. He loves to eat alfalfa and relishes being brushed.

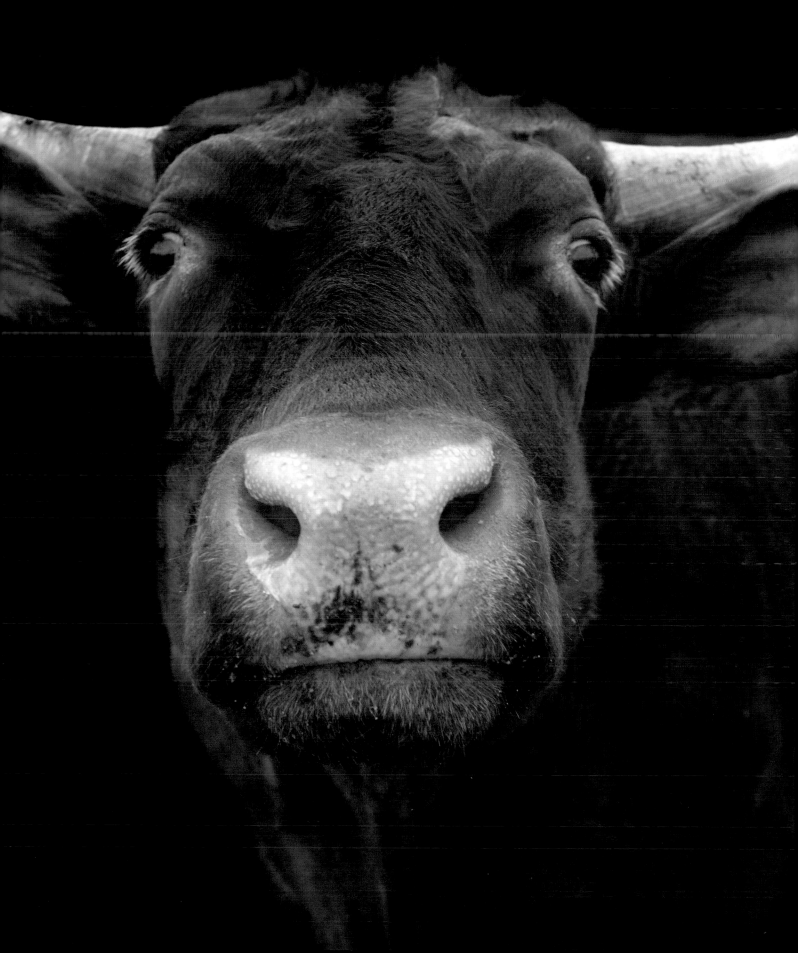

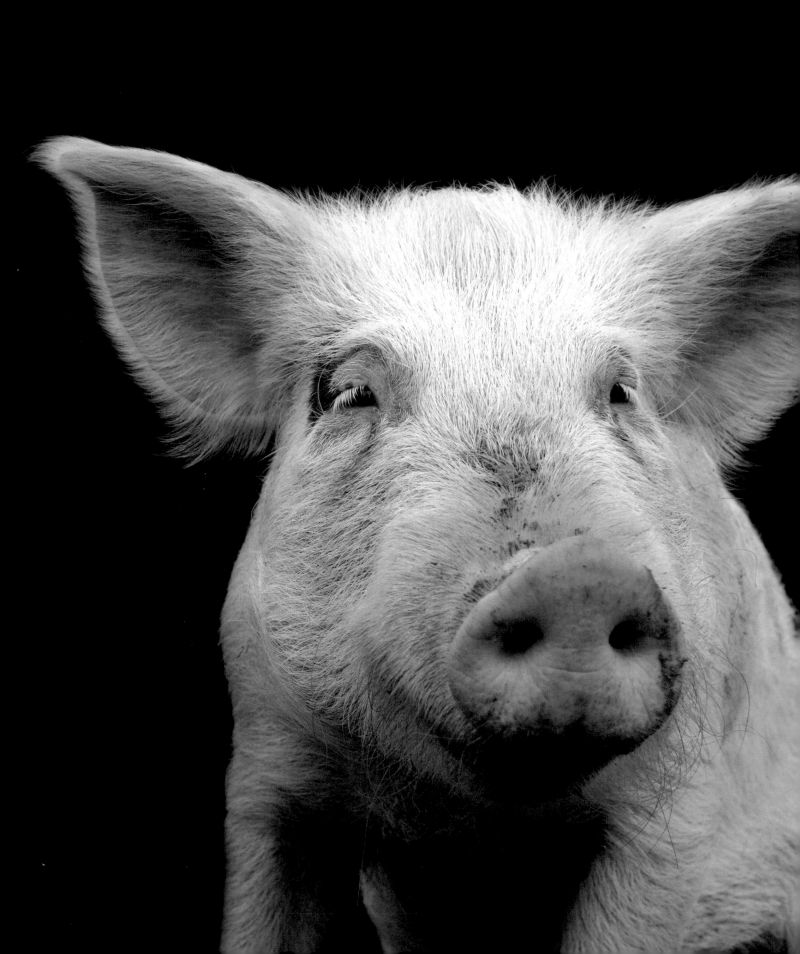

BEN DAVID

YORKSHIRE CROSS PIG

Evidence suggests that pigs were domesticated from wild boars as far back as 13,000 BCE, making them possibly the second-earliest species of mammal to be domesticated, after the dog. Pigs have relatively poor eyesight but an excellent sense of smell. Pigs instinctively root (repeatedly push or nudge) with their snouts. They use rooting as a way to find food, to communicate, and to find their mother's milk immediately after birth.

Ben David was born a runt on a small backyard farm, where he was one of five surviving siblings. The farm's caretakers gave him to a local woman who bottle-fed him, potty trained him, and raised him in her home, but as he grew, she knew that she could not keep him forever, so she reached out to a sanctuary to take him in. Because he had been taken from his biological mom almost at birth, he became very attached to Honey, a gestation sow at the sanctuary who has acted as his surrogate mother.

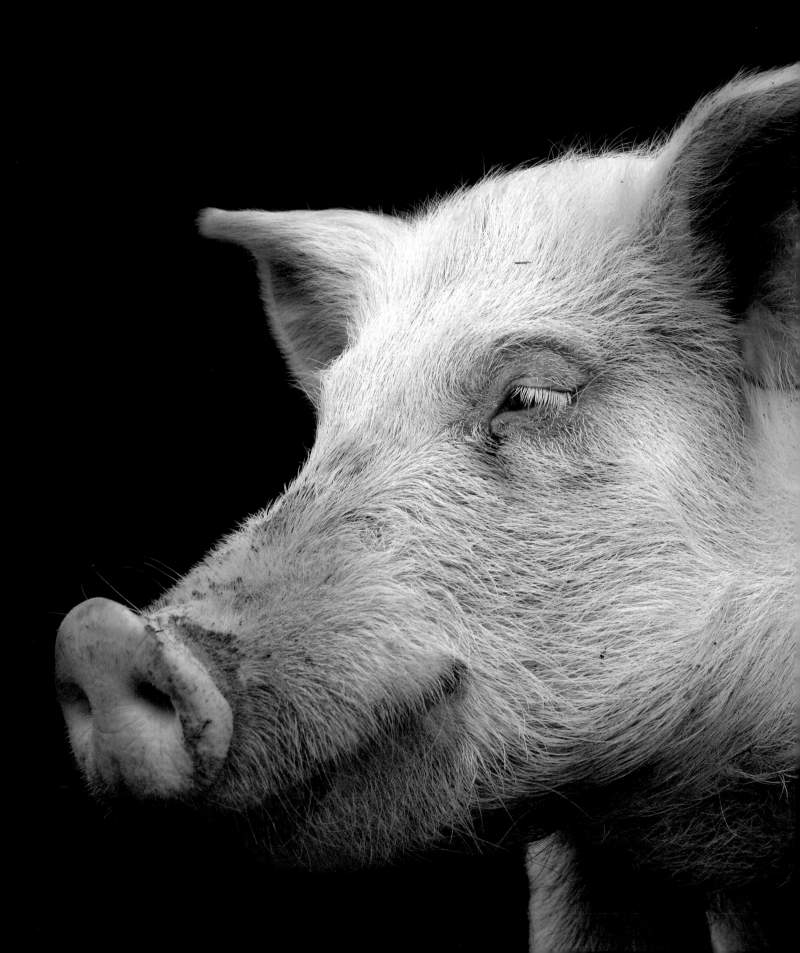

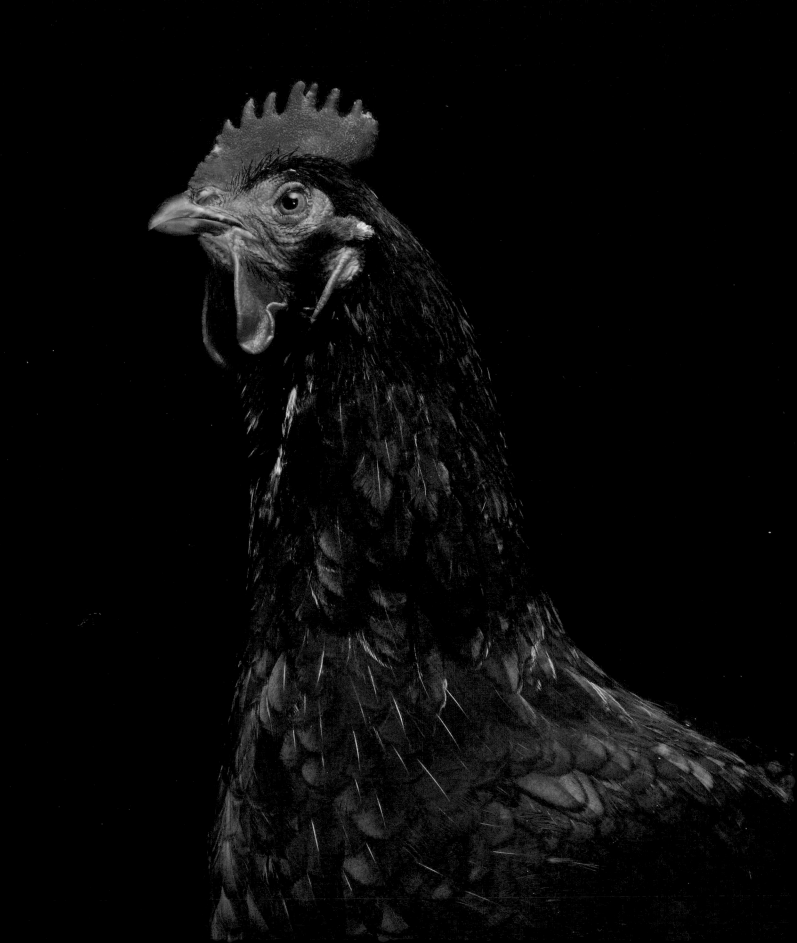

STELLA

BLACK STAR CHICKEN

Black Star chickens are a cross between a Rhode Island Red or
New Hampshire rooster and a Plymouth Rock hen. They are also
"sex link" chickens, which means they are bred so that males
and females are different colors. Black Stars are friendly, calm,
and resilient.

Stella is a beloved pet who underwent two hours of surgery and
received many stitches after a near-fatal coyote attack. She now has
completely recovered and leads the brood when called in by their
"mom" for the night.

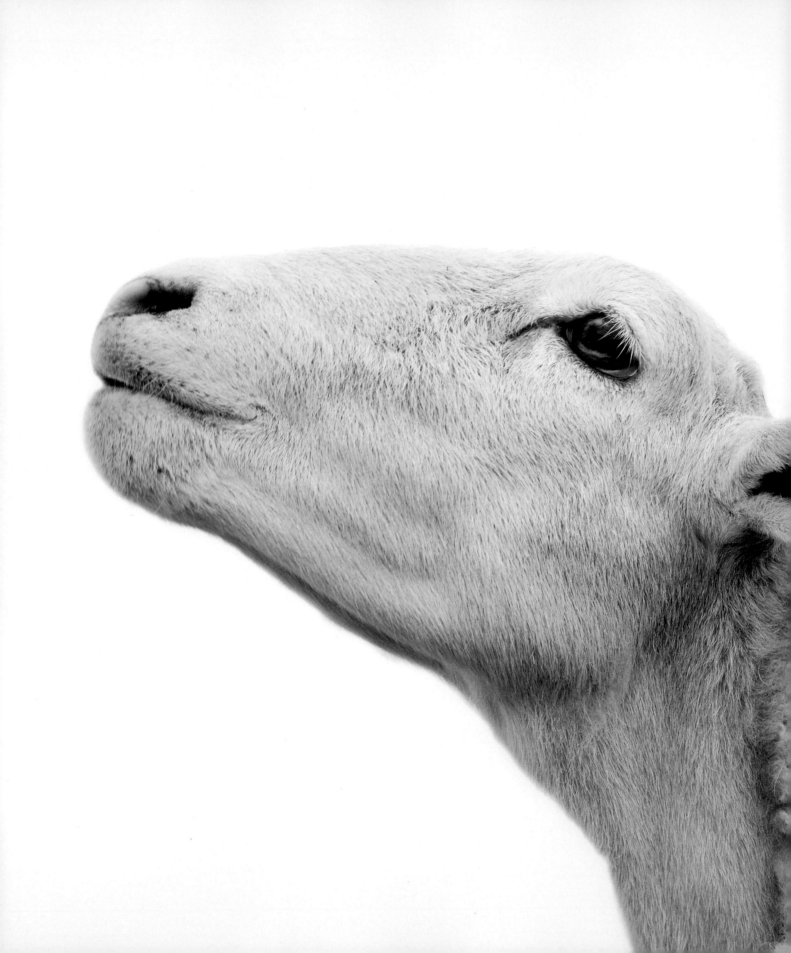

KARL

HAIRED SHEEP

Haired sheep have "hair" instead of wool and don't need to be shorn. Historically, haired sheep are considered the ancestors of all modern sheep. They were domesticated in the Fertile Crescent over 8,000 years ago. It wasn't until about 3000 BCE that humans began selectively breeding ancient sheep to produce woolly stock.

Karl is between six and eight years old. He is a survivor of extreme neglect and after his rescue had to spend two months in the hospital to treat an infection. Sheep are often quite skittish, but Karl is remarkably affectionate: he loves people and head rubs and hugs. He plays with other sheep and even the goat that he shares the sanctuary with. Every fall he grows a thick undercoat to stay warm during the winter months and then simply rubs it off in the spring, whereas his woolly counterparts must be shorn to remove their thick winter coats.

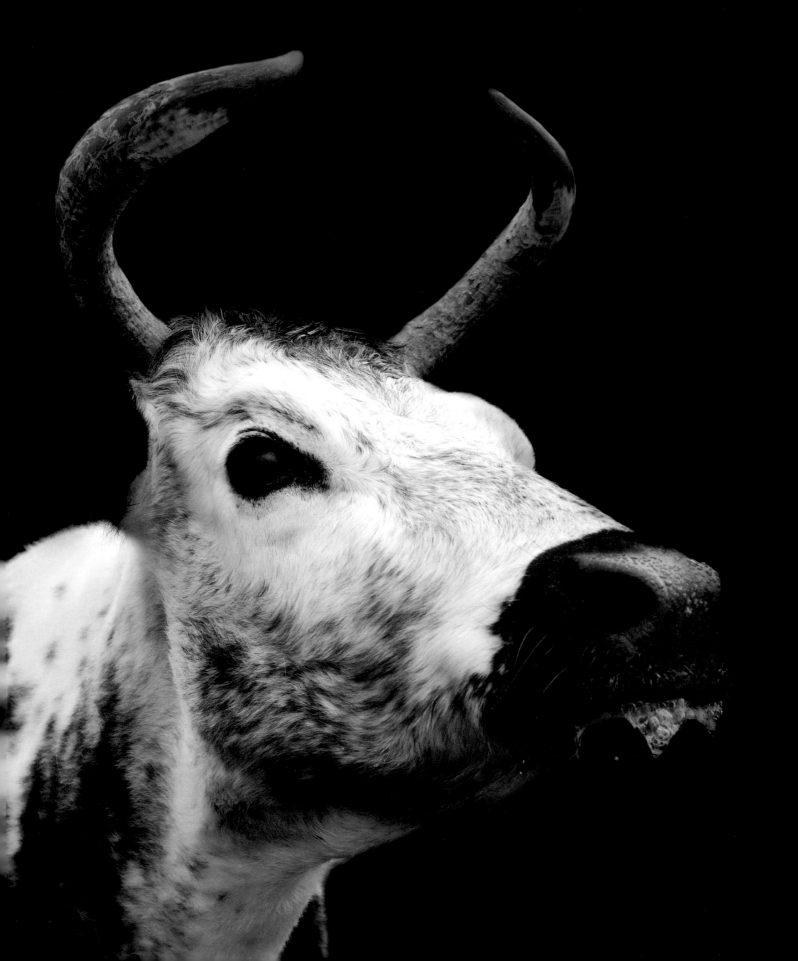

FERN

RANDALL LINEBACK COW

Randall Lineback cattle are a rare breed of purebred cattle that were
developed on a family farm in Vermont belonging to the Randall family.
Samuel Randall and subsequently his son Everett kept a closed herd
for over eighty years. Upon Everett Randall's death in 1985, the herd was
taken from the family farm and dispersed; many were lost to slaughter,
and the breed began to disappear. Through the efforts of individuals
and members of the Livestock Conservancy a small part of the herd was
saved and has been the foundation for conservation efforts.

Fern is seventeen years old. She is calm and easygoing and gets along
with everyone, but is especially close with her daughter Daisy, who lives
in the pasture with her. Mother and daughter have been inseparable
since Daisy's birth. Fern loves alfalfa cubes and being scratched under
the chin by her human friends.

BOBBERT

HUACAYA ALPACA

..

Alpaca are charming, quirky, gentle animals that often express them-selves through humming. The sound has been described as a musical purring, which alpacas use to communicate a range of emotions including contentment, curiosity, anxiety, or even boredom.

Bobbert likes to express himself through affectionate actions like kissing and nibbling on clothing. He loves being petted by people and hanging out with his pack of alpaca.

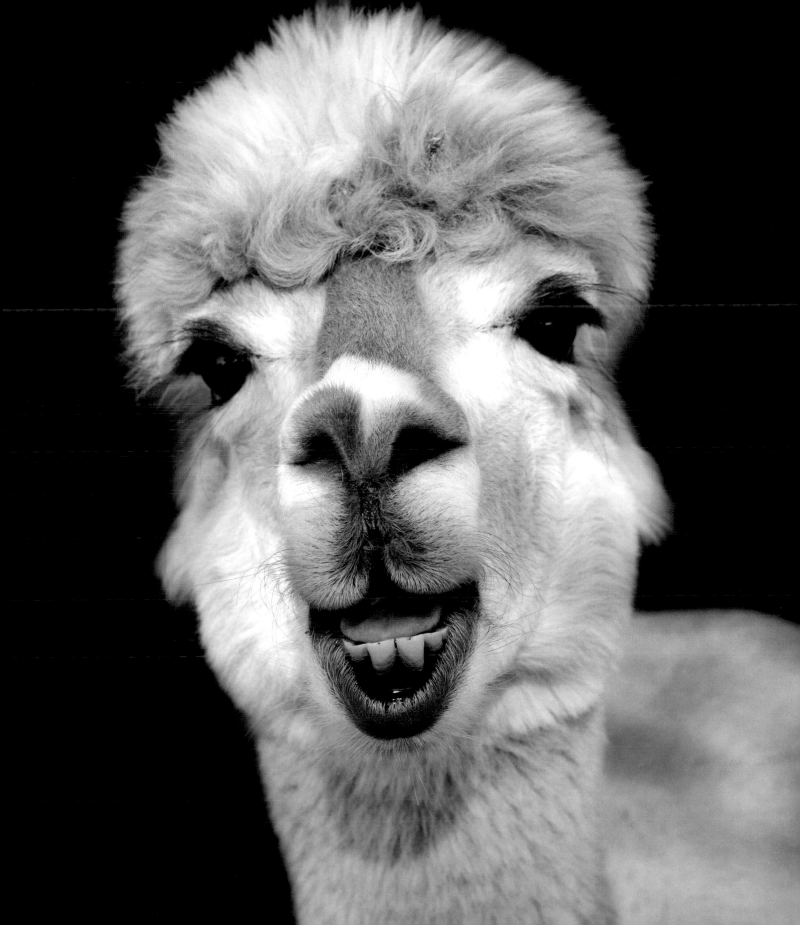

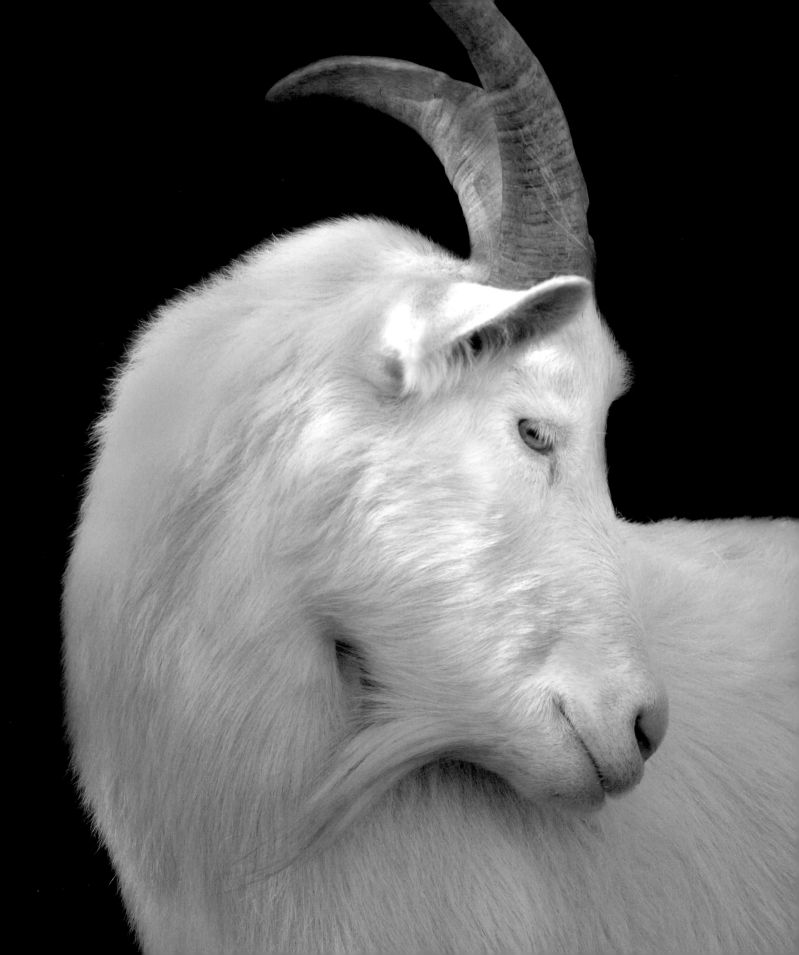

ARCHIE

SAANEN GOAT

Saanen goats are a breed of large Swiss dairy goat. Males, or billies, stand almost three feet at the shoulder. Underneath the lustrous white coat of a Saanen is equally white skin.

Archie is an older male goat who was taken, along with over one hundred other animals, from a backyard breeder/butcher. He was grossly underweight and having trouble walking. He was soon diagnosed with a type of brain worm that causes damage to the central nervous system. He underwent treatment and now thrives at the sanctuary. He is very attached to another goat from the same rescue and also likes to nibble the noses of human visitors.

SPOT

MUSCOVY DUCK

Muscovy ducks are large ducks with long necks; they often are confused with geese. Although truly wild, solid black Muscovy ducks can be found only in the southern parts of North America, domesticated black-and-white versions are common in parks and farms across the United States. Muscovy ducks are one of the oldest domesticated fowl species in the world. The earliest Spanish explorers found Muscovies being kept by native people in Peru and Paraguay. It is also said that Aztec rulers wore cloaks made from their feathers.

Spot is the friendliest duck at the sanctuary. He loves meeting visitors and volunteers at their cars. He waddles up to the car door and then follows them around, hoping for treats. Spot is four years old. His mother was a wildlife rehab patient at the sanctuary who was treated and then released but later returned with newly hatched chicks in tow.

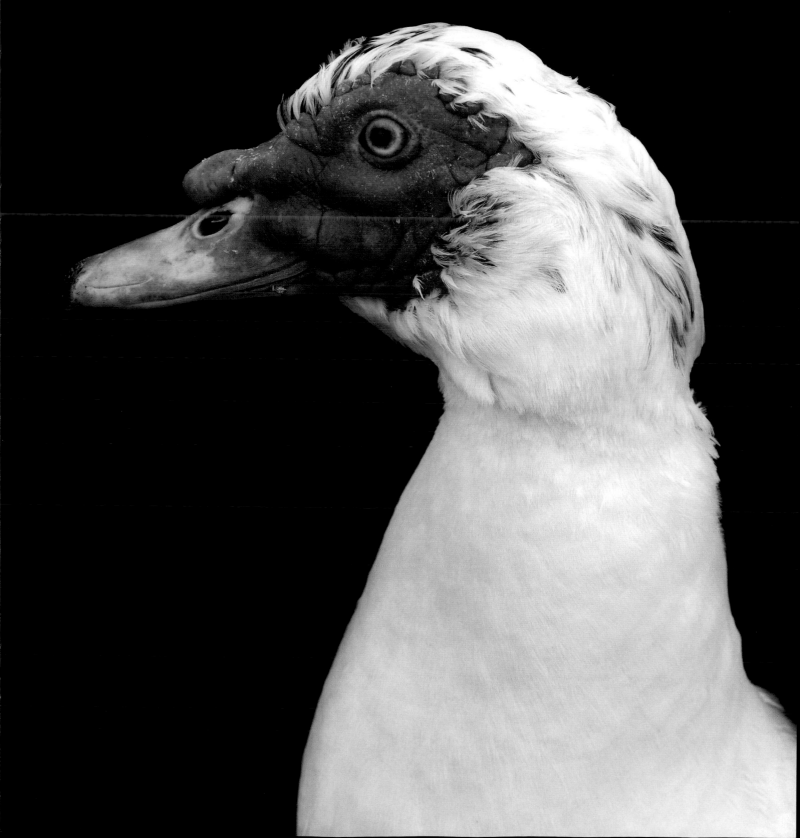

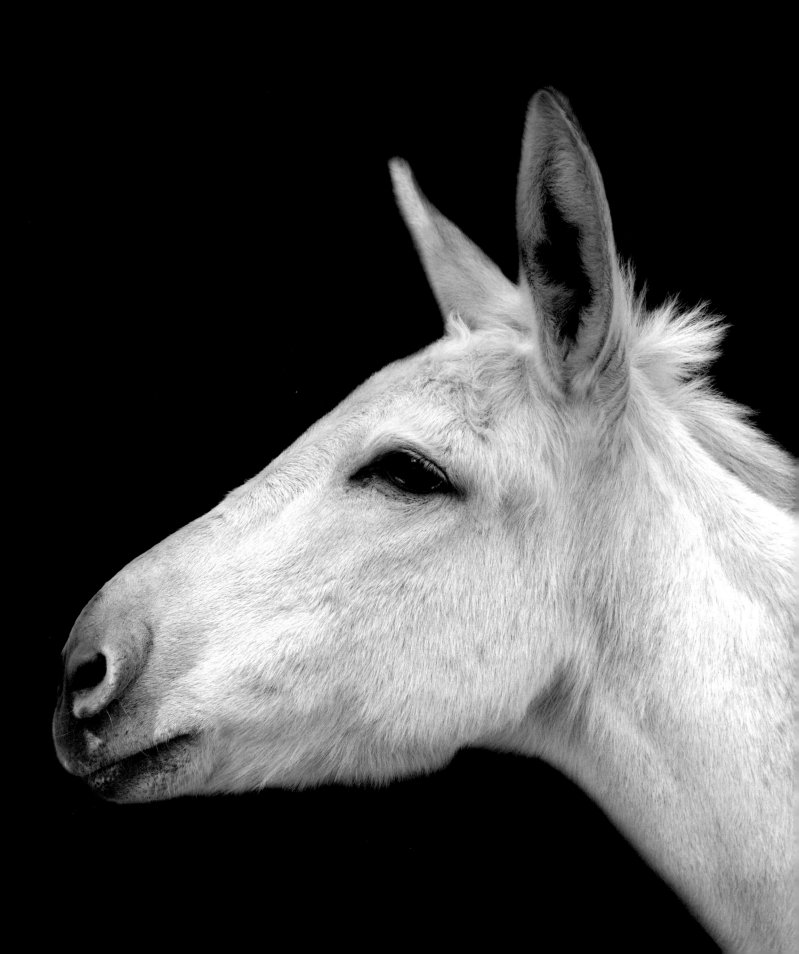

STARDUST

WHITE DONKEY

Donkeys are domesticated members of the horse family and have been used as working animals for over five thousand years. The donkey's characteristic stubbornness is actually a strong self-preservation instinct, which makes them reluctant to enter into any situation they perceive as dangerous.

Stardust was rescued in the 1990s from a meat auction, where donkeys and other animals were sold to be made into dog food. He is over thirty years old, making him quite an old donkey (a donkey's average lifespan is twenty-five to thirty years). Stardust loves to run through the woods on his sanctuary and play with his best friend, Zorro, a miniature donkey. Stardust is shy with strangers but is affectionate with his caretakers.

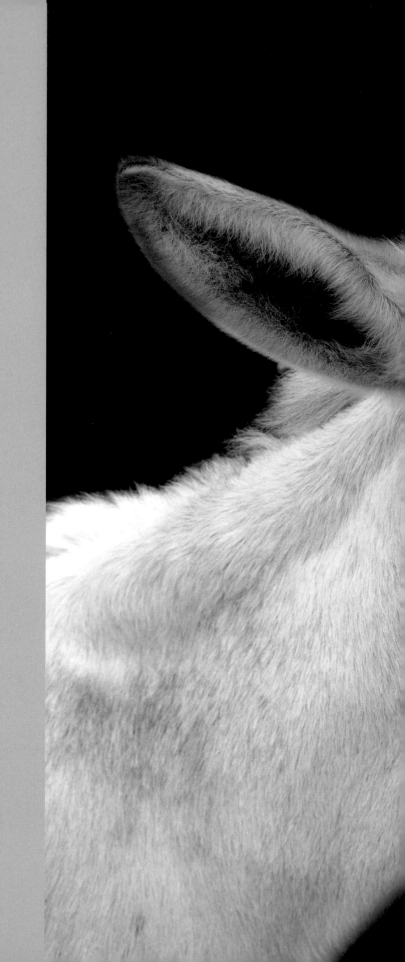

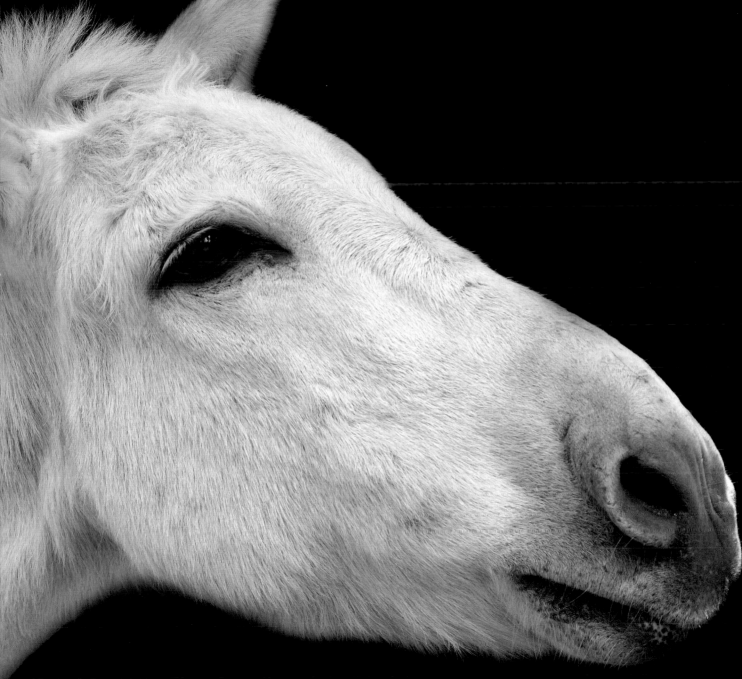

HENRI

SLATE HERITAGE BREED TURKEY

..

Turkeys are uniquely American birds. All domestic turkeys are
descended from wild turkeys once indigenous to North and South
America, but Heritage breeds include around a dozen types of domestic
turkeys that retain traditional characteristics no longer present in the
white turkeys raised in the United States for meat consumption since
the rise of factory farming. Among other criteria, Heritage turkeys
have a slower growth rate, which allows them to mature naturally and
be healthier than their mass-produced cousins. By the late twentieth
century, Heritage turkeys had become all but extinct but are now
making a comeback among small farmers and hobbyists. It is estimated
that there are fewer than five thousand breeding Slate turkeys in the
United States.

Heritage turkeys are known for their beautiful plumage and colorful
wattles, and Henri is a stunning example. Henri is six years old and
absolutely loves hanging out with chickens. He roams the grounds
of the sanctuary and looks after his flock, while strutting and making
fantastic drumming sounds with his chest. His favorite snacks are
grapes and watermelon.

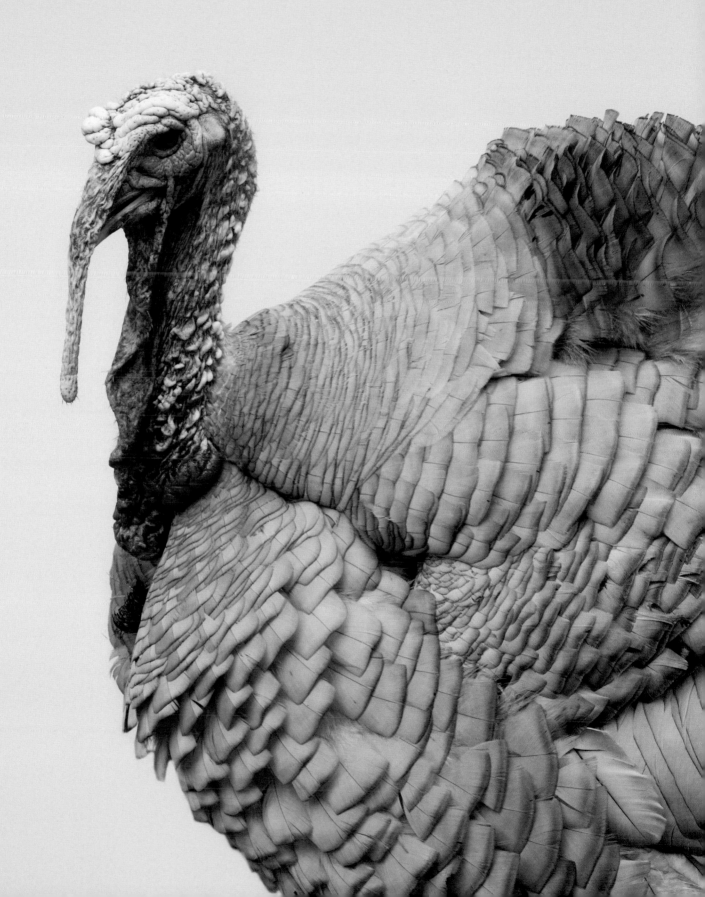

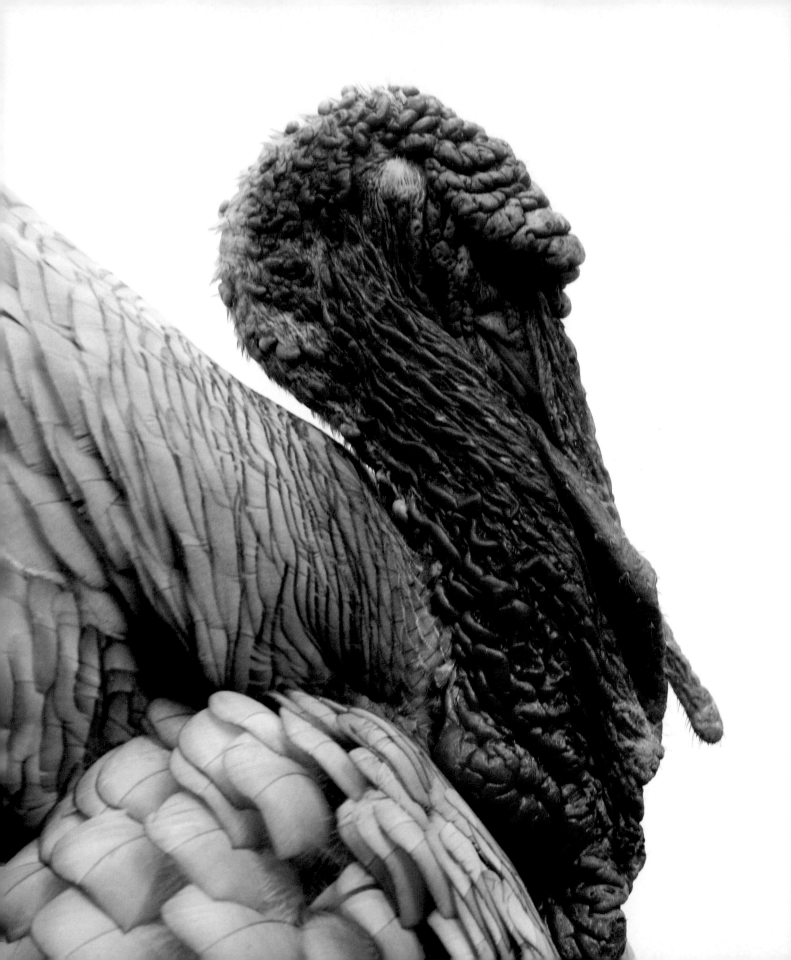

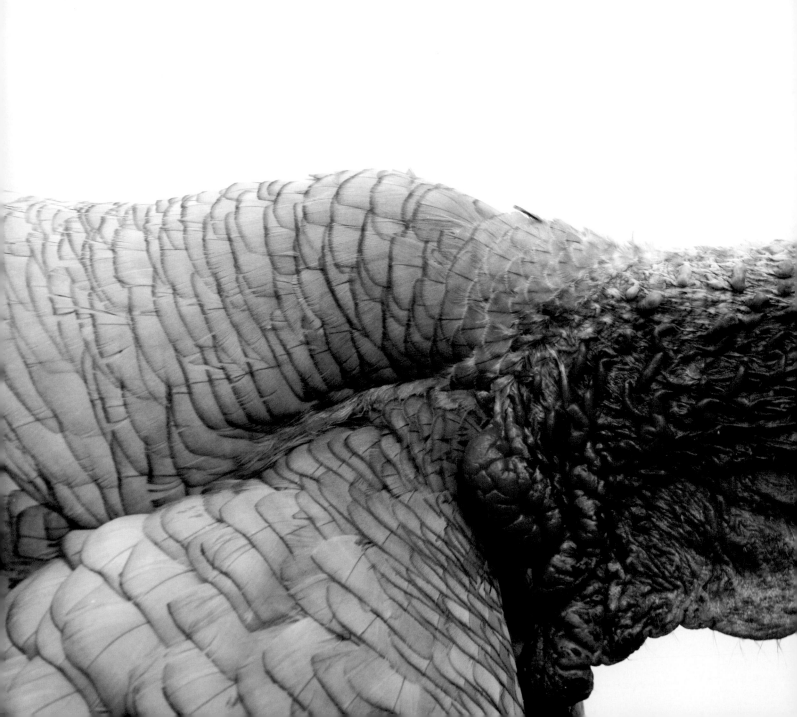

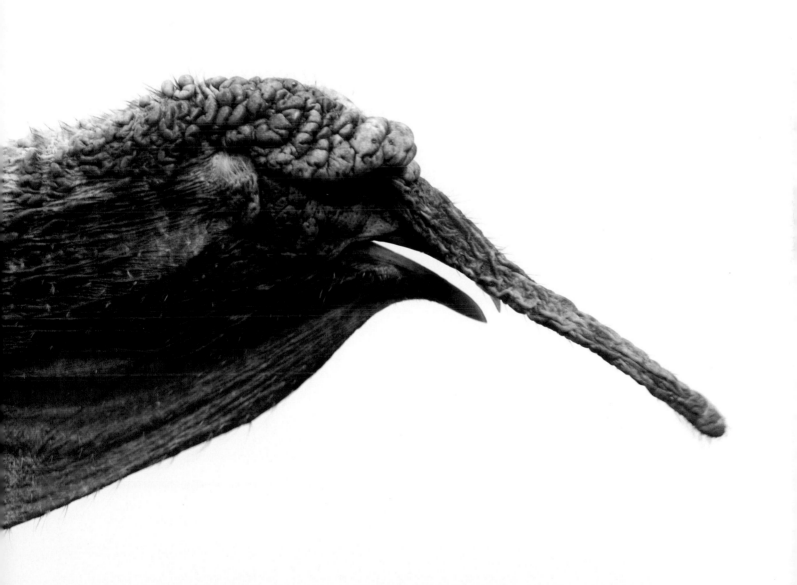

TUCKER

GUERNSEY COW

..

Guernsey cattle are dairy cows from the island of Guernsey in the
British Channel Islands; however, like all dairy breeds, only female
calves are kept for dairy, while male calves are auctioned off soon after
birth and raised for meat. Guernsey cattle were originally brought to
the island in the Middle Ages for plowing and pulling carts.

Tucker is truly a gentle giant. Weighing in at over 2,500 pounds,
he is six feet tall at the shoulder and is described as being "gentle as
a golden retriever." He loves chin and forehead scratches from humans
and also enjoys being groomed and bathed. Tucker was bought by
a petting zoo soon after birth and kept as an attraction. After visiting
Tucker all summer at the zoo, a mother and daughter were horrified
to learn that he was being sent to slaughter at the end of the season.
They purchased him and then called a sanctuary, which took him in.
Tucker is a favorite with absolutely everyone who meets him.

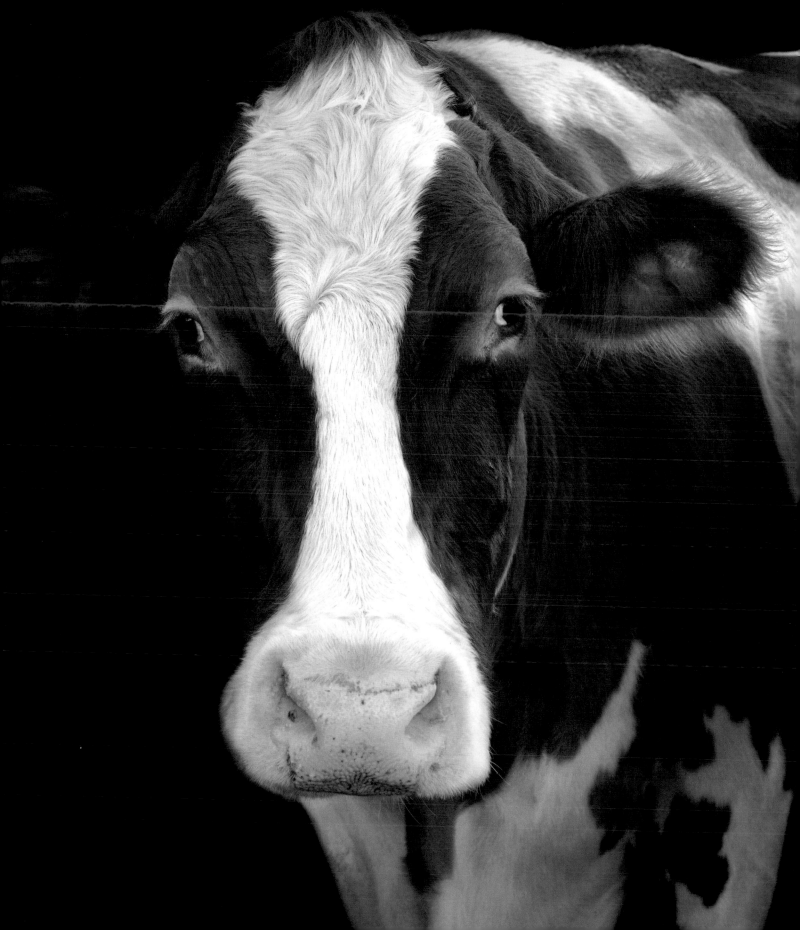

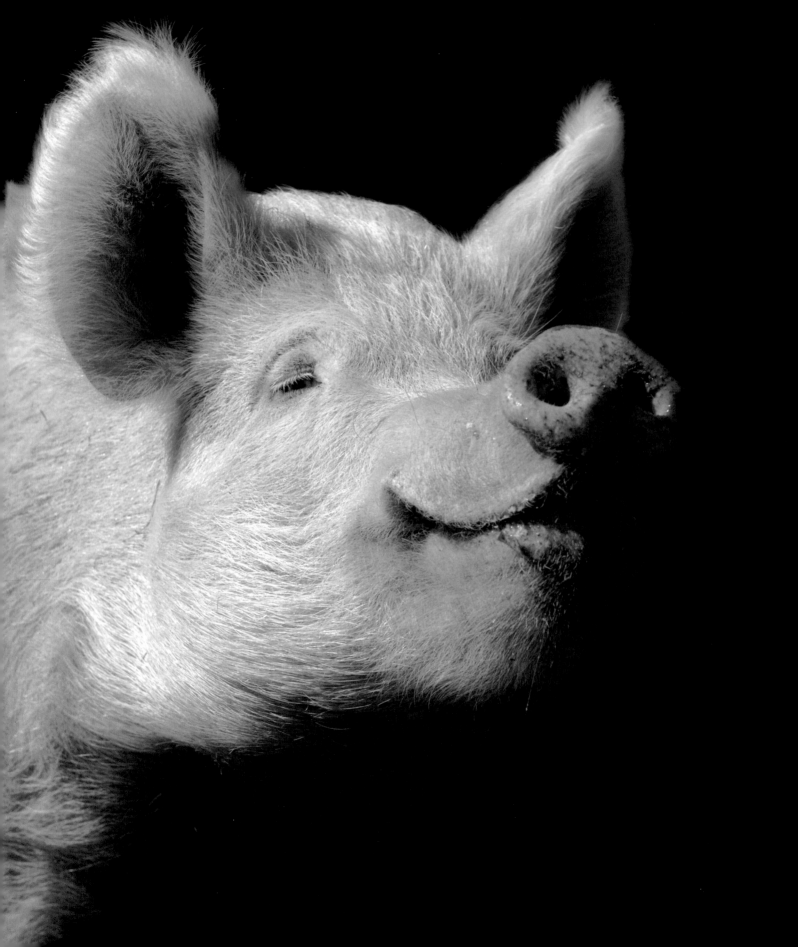

AMELIA

AMERICAN YORKSHIRE PIG

Yorkshire pigs are the classic definition of most people's mental image
of a pig. Their pink skin is covered in thin, white hair; their ears
are long and perky; and they have curly little corkscrew tails. Although
Yorkshires can live six to ten years and reach a weight of 650 pounds,
the vast majority are sent to slaughter by the age of six months.

Amelia is six years old. She was rescued at three months from a convicted
animal abuser in upstate New York; the woman had started breeding
pit bulls and was planning to use Amelia as bait to train the dogs. At the
sanctuary, Amelia enjoys spreading fresh bedding in her house and taking
cool mud baths on hot days. She has also been known to steal tools
from caregivers while they are visiting or fixing something in the barn.

CLEMENTINE

BUFF ORPINGTON CHICKEN

Named after the town of Orpington, Kent, in England, this breed of chicken is a "dual purpose" chicken, which means it is raised for both meat and eggs. Buff Orpingtons were a favorite of Queen Elizabeth, the Queen Mother, and her flock reportedly earned several awards.

Orpingtons are known for being big and friendly, and Clementine does indeed love people, despite her tumultuous past with them. Clementine was left at a bar one night as an odd prank. The bar patrons apparently spent the evening trying to find a home for her but had no luck. Eventually she was delivered to a wildlife rehabilitator, who in turn brought her to a farm sanctuary. Clementine may love people, but it's said that she loves birdseed even more. She often breaks out of her pen and waits beneath the bird feeder. When squirrels inevitably drop the seed, she snatches it up.

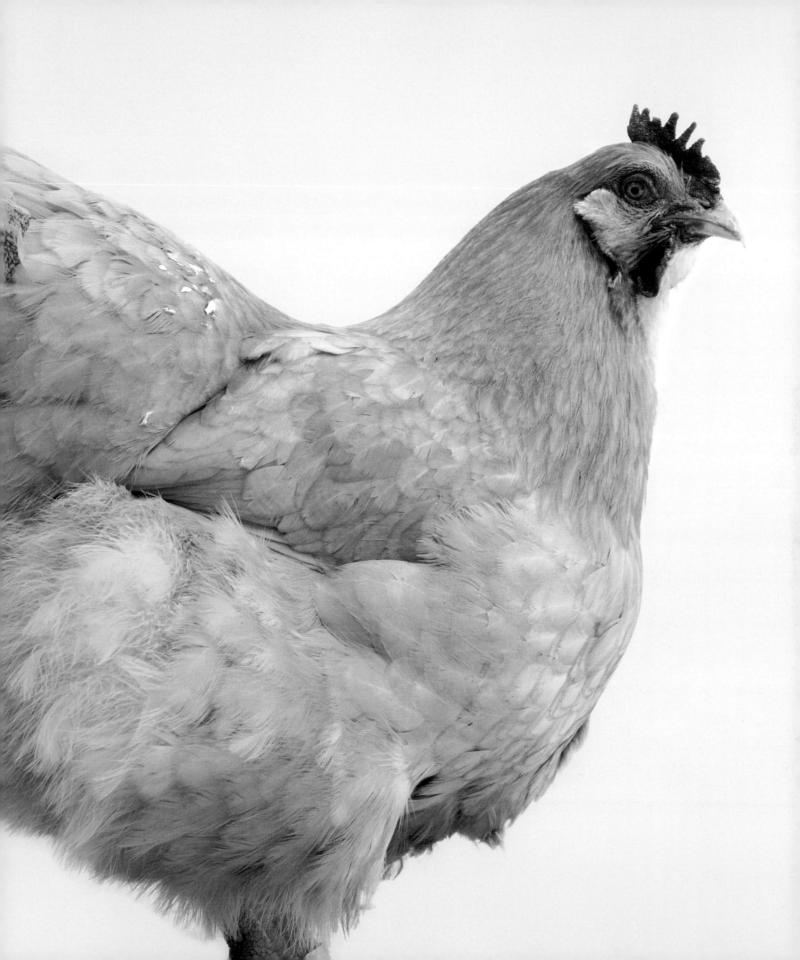

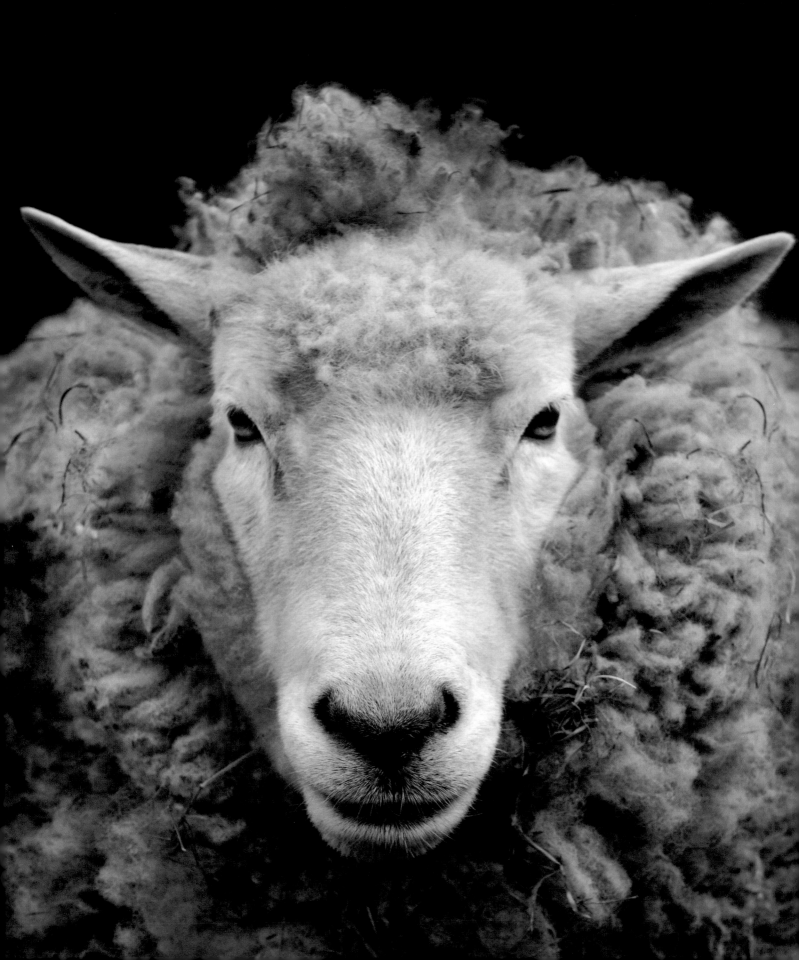

TARA ANNA

ROMNEY SHEEP

Romney sheep are long-wool sheep that produce a heavy fleece. Originally from Kent, England, this hardy breed was first exported in the mid-nineteenth century and can now be found all over the world. Romney fleece is prized for quality wool, and the lambs are raised for meat.

Tara Anna was brought to a sanctuary after police found her being beaten by a group of people using her as a living piñata. Despite the immense cruelty she suffered, after many years, she began to trust people again, letting them get near her but never too close. She became intensely bonded with other sheep, goats, pigs, and llamas at the sanctuary. Tara Anna passed away from old age in 2017. She had lived twelve peaceful years at the sanctuary.

MOO

JERSEY HOLSTEIN CROSS COW

. .

Crossbreeding cows and other livestock is a common practice in farming. Often the best attributes of two different breeds can be combined and even enhanced in a new crossbreed, plus their offspring are often considered stronger and healthier because of hybrid vigor, which is the tendency of a crossbred animal to show qualities superior to those of both parents.

Moo was born on a dairy farm. Male calves born to dairy cows are sold almost at birth to be raised as beef or veal. Moo would have become a veal calf had he not been taken in by a sanctuary. Moo is very gentle and friendly, and is the head of his herd. He is in a special-needs herd because he has arthritis. Moo loves children, and the baby cows in the herd are particularly fond of him.

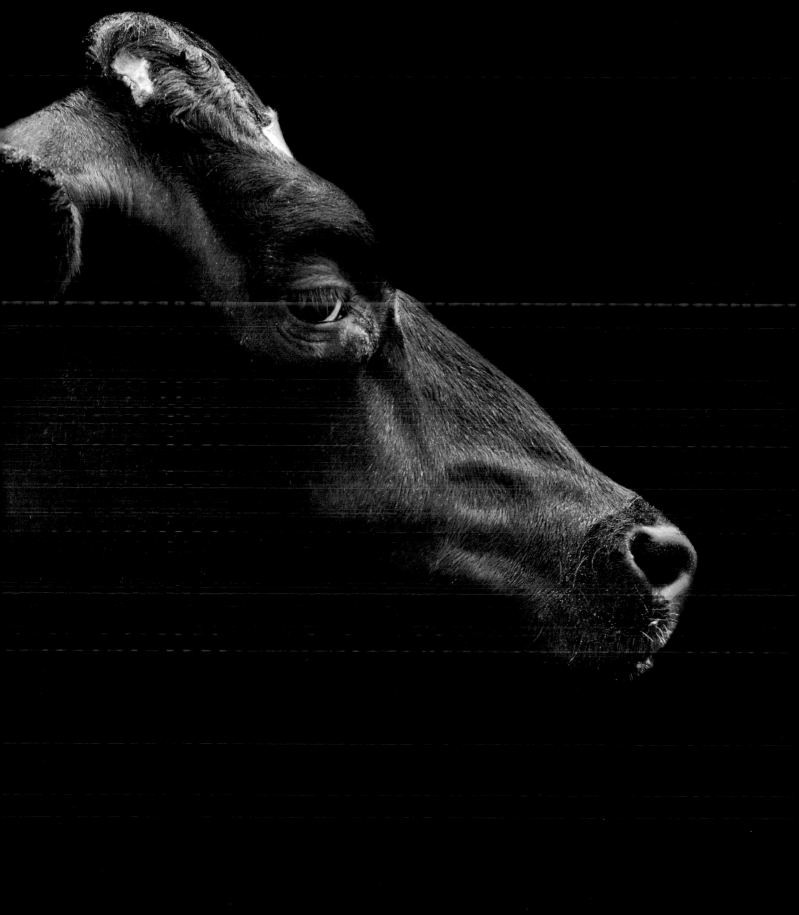

KONJA

LLAMA

People are often afraid of being spit on by a llama, even though it's a rare occurrence. The practice of spitting is used, however, within the llama herd to discipline lower-ranking members. Males will often fight to establish dominance in addition to spitting. Llama fights are very dramatic, with males kicking each other, wrestling with their necks, and chest bumping to try to knock each other off balance, but despite the display, the participants are very rarely injured.

Konja was born at a working farm that soon after made a drastic change and became a sanctuary. As such, he grew up in a tranquil setting with his mom and still lives with her today. Konja is over twenty years old and now is considered an elderly llama, but he still likes to meet new friends and make funny faces at them.

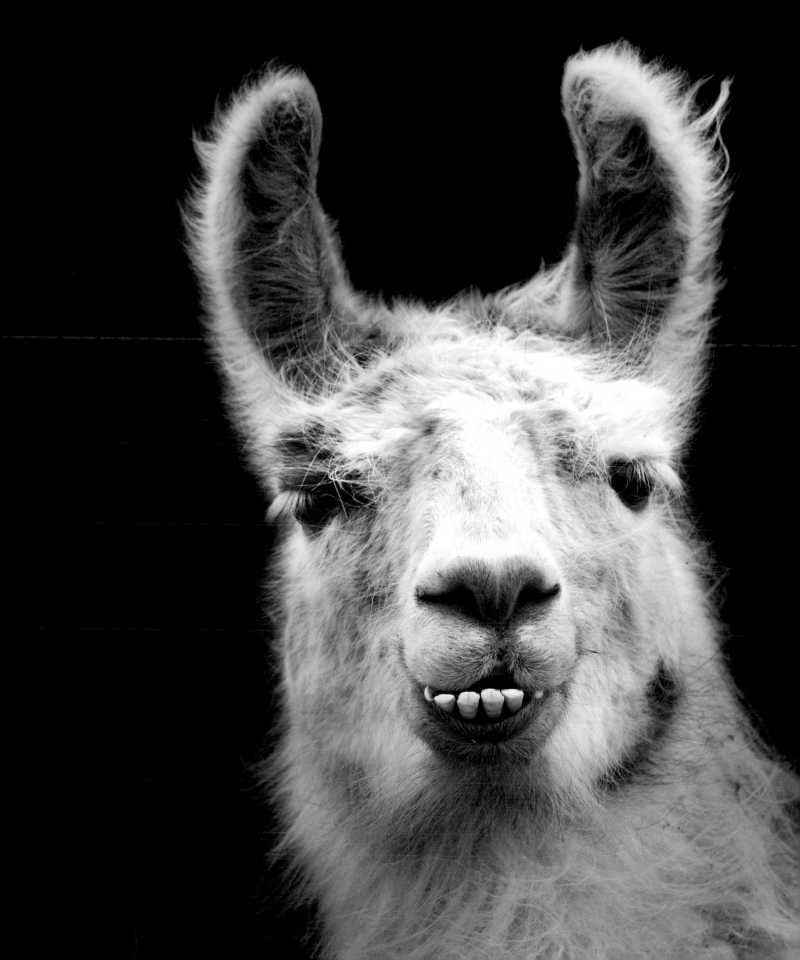

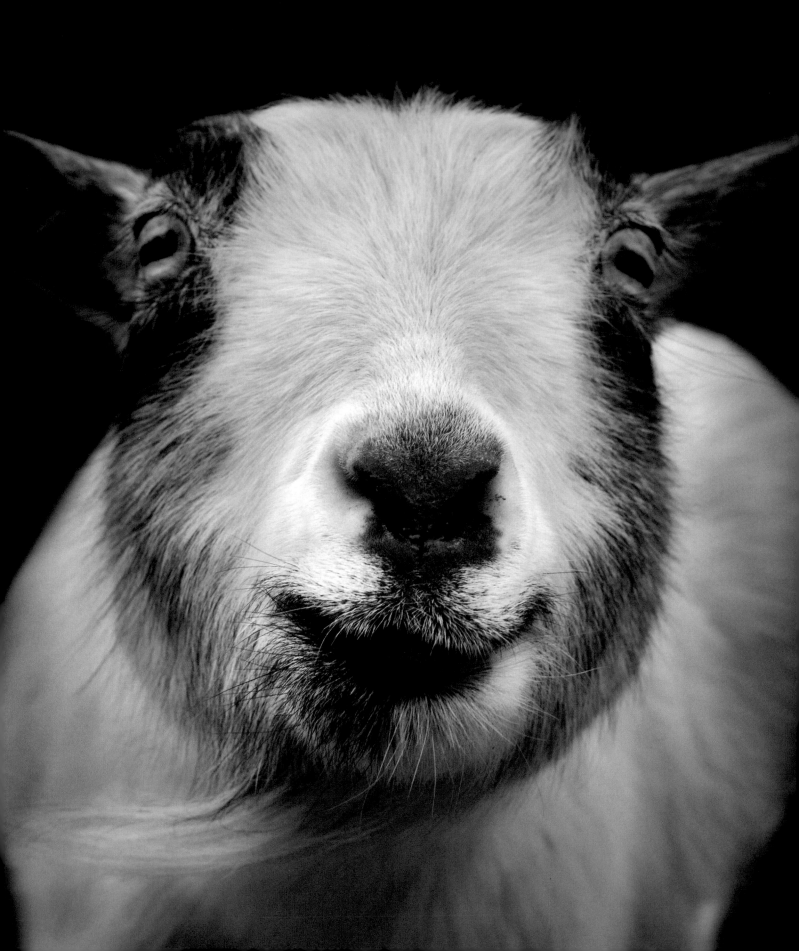

MARCIA

NIGERIAN DWARF GOAT

..

Nigerian Dwarf goats are a miniature goat breed from West Africa
that came to the United States in the 1950s. They are prized as both
milkers and companion animals. Nigerian Dwarf goats are gentle
yet playful, smart, and quick to learn, all of which makes them very
popular pets, especially for children. Some Nigerian Dwarf goats
have even been known to work as service and therapy animals.

Marcia, like most Nigerian Dwarf goats, loved children. She was
a spunky, spirited goat who enjoyed going for walks and having her
back scratched. Her favorite snack was grapes. Since this photo
was taken, Marcia has passed away from cancer.

PENG

CHINESE GOOSE

...

Chinese geese are a popular breed of domestic goose. Often called swan geese because of their long and graceful necks, Chinese geese are actually descended from wild swan geese. Chinese geese grow distinctive knobs on their foreheads, the size of which helps determine gender; male geese, or ganders, have larger, more pronounced knobs. Gender can be determined in chicks as young as six weeks old, but usually not before.

Peng and four other Chinese geese were being raised for slaughter. A neighbor who was determined to save them called the sanctuary and said that she could buy the geese but would have nowhere to keep them, so the sanctuary agreed to take them in if she acquired them. The quintet roams the sanctuary freely in pairs and small groups.

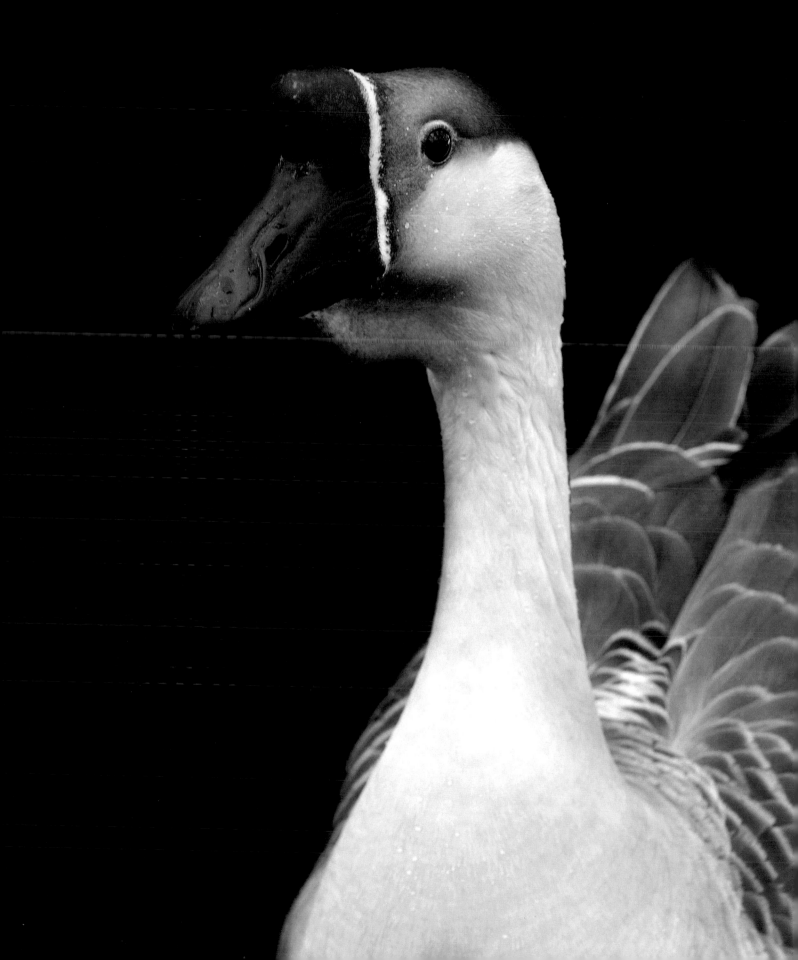

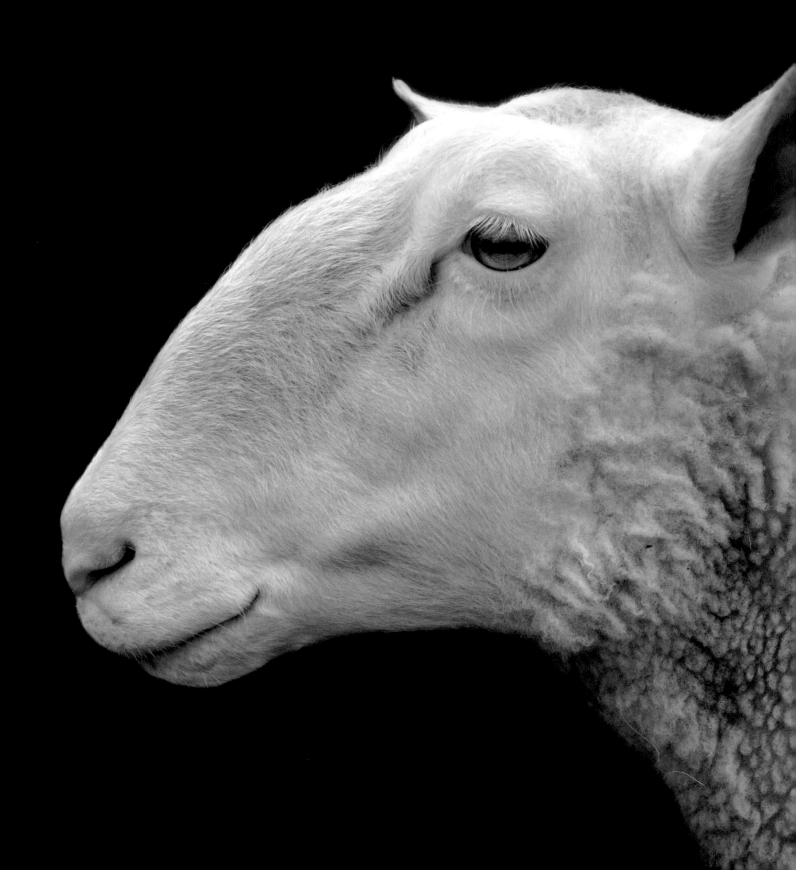

HAZELTON

EAST FRIESIAN SHEEP

East Friesian sheep originated in the Friesland area of northern coastal Holland and Germany. They are the world's highest-producing dairy sheep, but they are also commonly crossed with other breeds of non–dairy sheep to increase milk production. The purebreed East Fricsian was introduced to the United States from Canada in 1994.

Hazelton's mom, Tracey, was a dairy sheep who came to a sanctuary along with another female from the same farm. Both ewes were heavily pregnant, severely emaciated, malnourished, and crawling with lice upon arrival. Hazelton was born at the sanctuary along with his cousins, Summer and Reuben. Though Hazelton was fragile at birth and had trouble nursing, with much help from the staff, he made it through the crucial first few weeks and eventually grew to be much larger than his mother. Hazelton lives with his mom and extended family and is said to be quite the mama's boy.

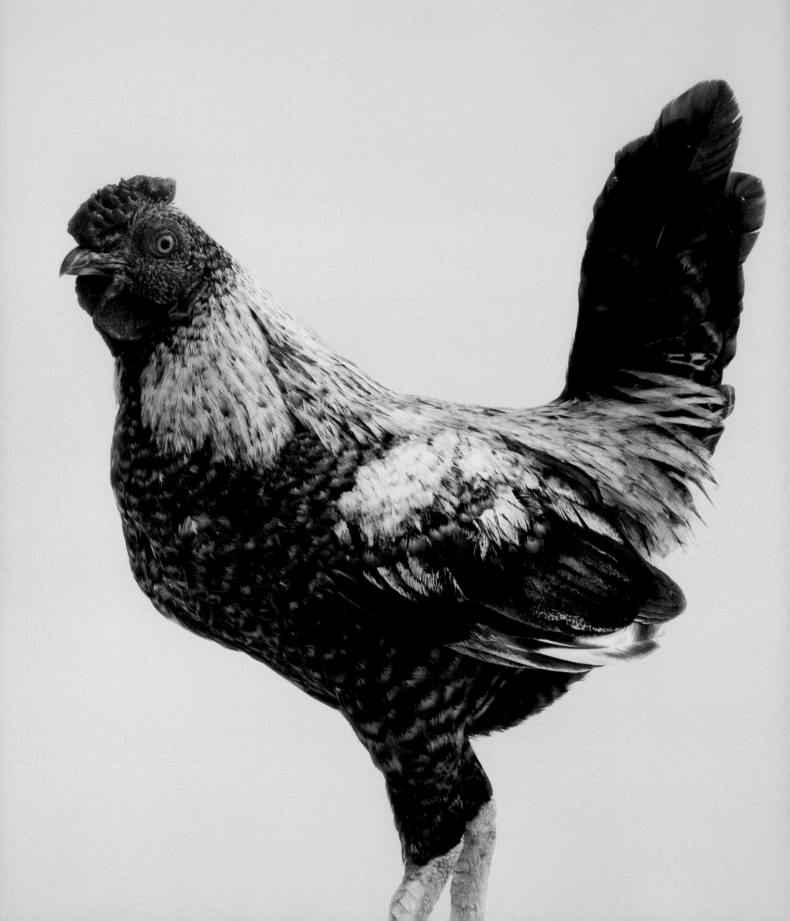

MILO GIBSON

BANTAM ROOSTER

Roosters act as protectors for the hens in their flock. The reason roosters seem to always be on guard is that they are. One of their jobs is to alert the flock to danger; in cases of actual physical threats, the rooster will try to fight or scare the perceived predator.

Milo weighs in at only 2.2 pounds but is considered the toughest bird on the whole farm. He came to the sanctuary with twenty-two hens. This flock is close-knit, and Milo is extremely protective of his ladies. He will take on just about any animal, including fifty-pound turkeys, if they wander into his patch.

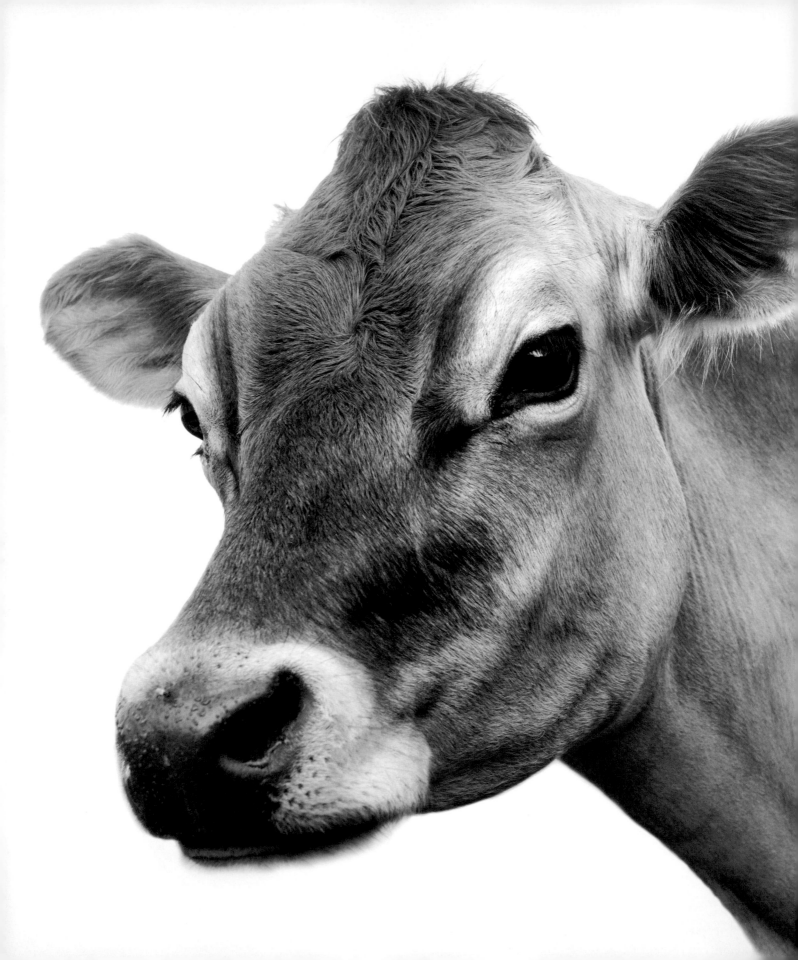

LIZ

JERSEY COW

Jersey cattle are the second most popular breed of dairy cattle in the world. They originate from the British Channel Island of Jersey, with official breed records dating back to 1700. Their milk is highly desirable because it has a high butterfat content and rich taste.

Liz came to a sanctuary from a dairy farm with her newborn calf, Cashew. She was producing far more milk than she needed for one little calf (sixty pounds a day!) and had mastitis, which she was treated for. As luck would have it, an orphaned calf, Jerome, was taken in by the sanctuary just weeks later. At first Liz was unsure about the new baby, but she soon decided to adopt him as her second calf. She nursed and raised both Cashew and Jerome, and they still live together today.

MARLEY

AMERICAN YORKSHIRE PIG

· ·

The Yorkshire pig was developed in England in the eighteenth century and first imported to the United States (to Ohio) in 1830. Today these pigs are found in almost every state, with the highest numbers in Illinois, Indiana, Iowa, Ohio, and Nebraska.

Marley was surrendered by a backyard breeder along with her ten siblings and then brought to a sanctuary when she was two to three months old. She is shy at first with people and waits until she sees her siblings warm up to someone before she does. Once she knows and likes someone, though, she loves belly rubs and ear scratches. She gets grumpy when her siblings wake her from naps and when her dinner is running late.

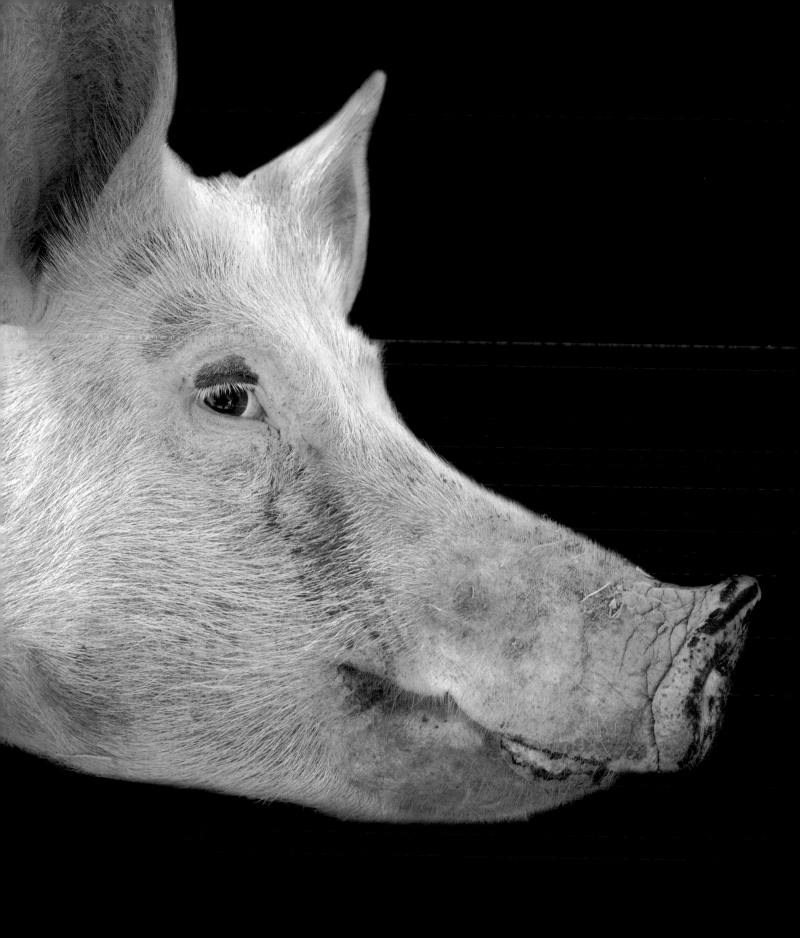

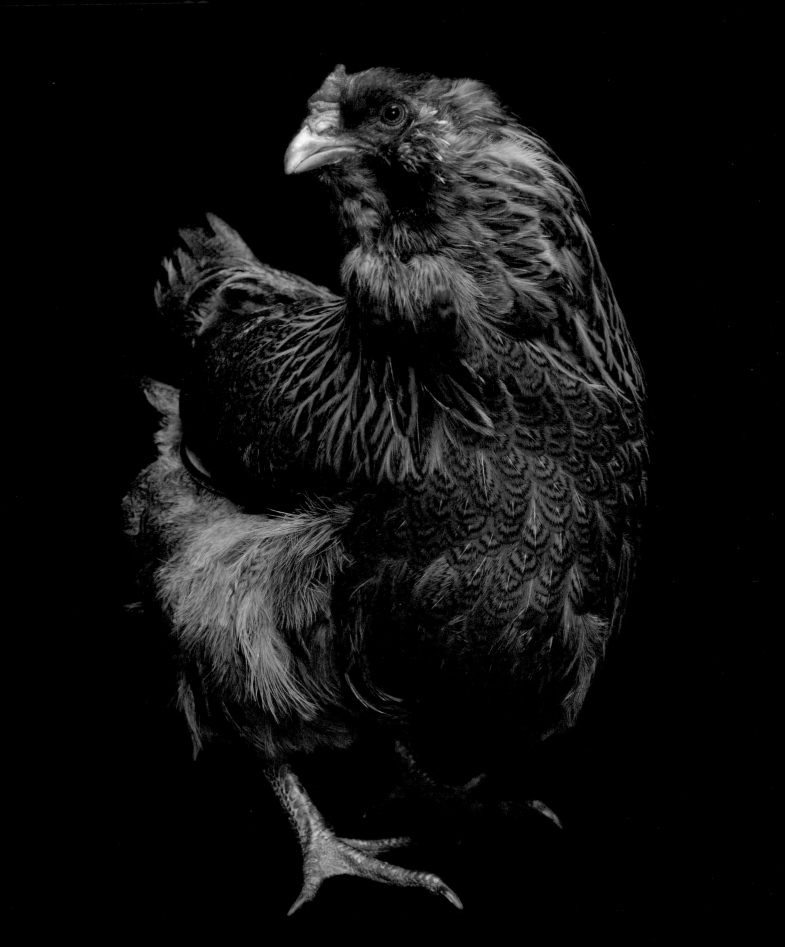

RUTH

AMERAUCANA CHICKEN

The Ameraucana hen is one of the only species of chicken that lays colored eggs. Sometimes called Easter Eggers, these bearded hens lay eggs in beautiful shades of blue and green. The eggs themselves are identical to those of other chickens—the only difference is the shell pigmentation.

Ruth is a pet chicken in a small flock. All flocks do indeed have a "pecking order" or dominance hierarchy that always leaves one individual at the bottom—which in this case is Ruth. Her owner says the other hens perpetually give Ruth "attitude," but she chooses to accept her role and not challenge her position. As such, she is a bit more reserved and solitary than the rest of the brood.

ERIN

KATAHDIN HAIR LAMB

..

The Katahdin Hair sheep is an American Heritage breed that was developed in Maine and named after Mount Katahdin, the highest peak in Maine. The breed was created by an amateur geneticist, with the goal of developing a new line of non-wool-producing meat sheep who would not need shearing. They are known for being excellent mothers.

Born and raised at the sanctuary, Erin is in fact very close with his mother, Julia. As a young lamb, Erin lived in a safe enclosure with his mom, but now he has joined the main sheep herd and is working to find his place in the world. He loves meeting people and is independent, curious, and fun.

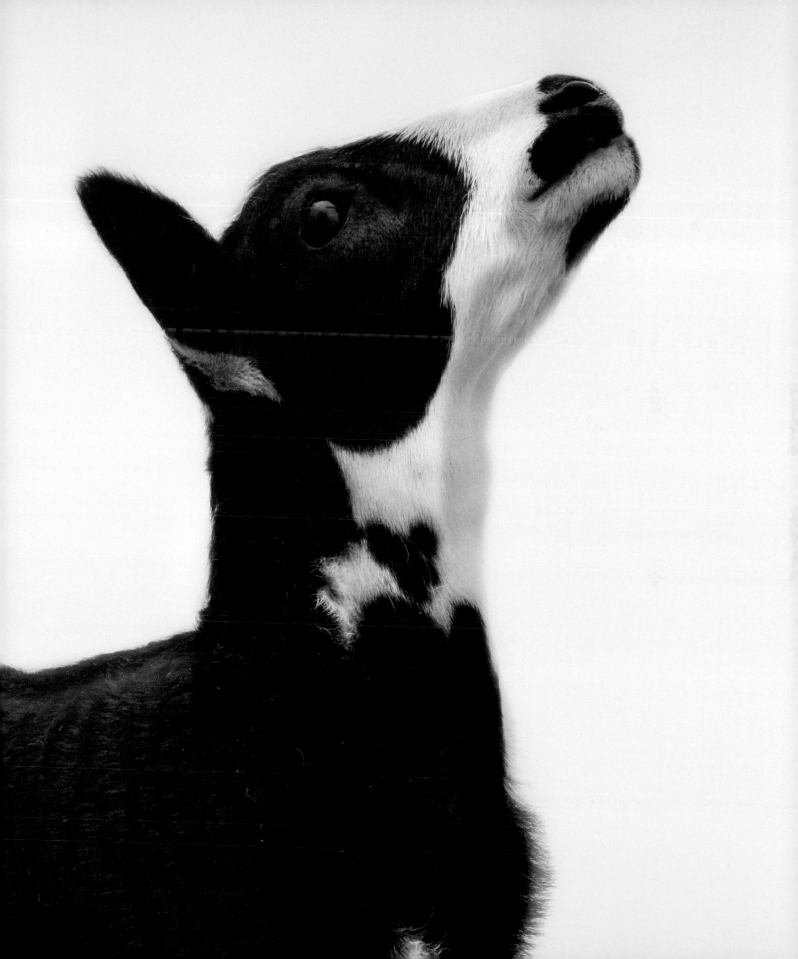

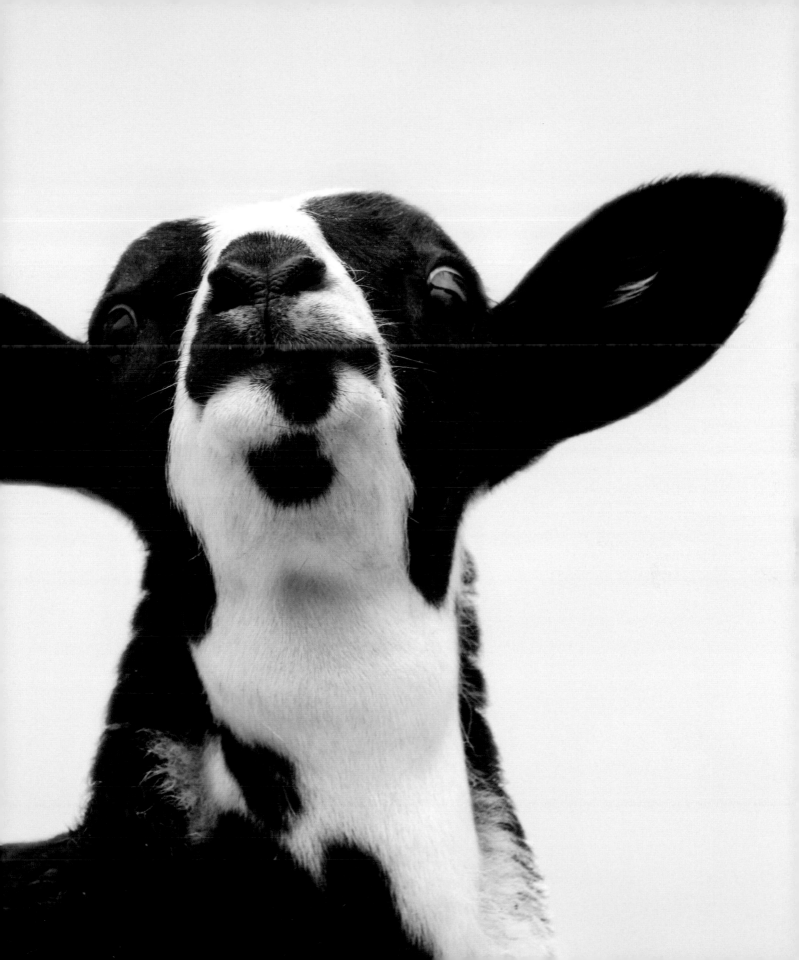

WALLACE

MINIATURE HIGHLAND COW

..

Scottish Highland cattle are the oldest registered breed of cattle in the world. These hardy beef cows were bred to endure harsh Scottish winters and have a double coat of fur. The long, shaggy outer layer is oiled to make them waterproof, while the soft, downy inner coat keeps them warm even in the coldest winters. Highland cattle are docile and unique looking, with long, reddish fur; twisty horns; and a shaggy fringe that hangs over their eyes.

Wallace was born in 2013 and spends all of his time with his best friend, another mini Highland named MacGregor. Their favorite treats are kale and fruit.

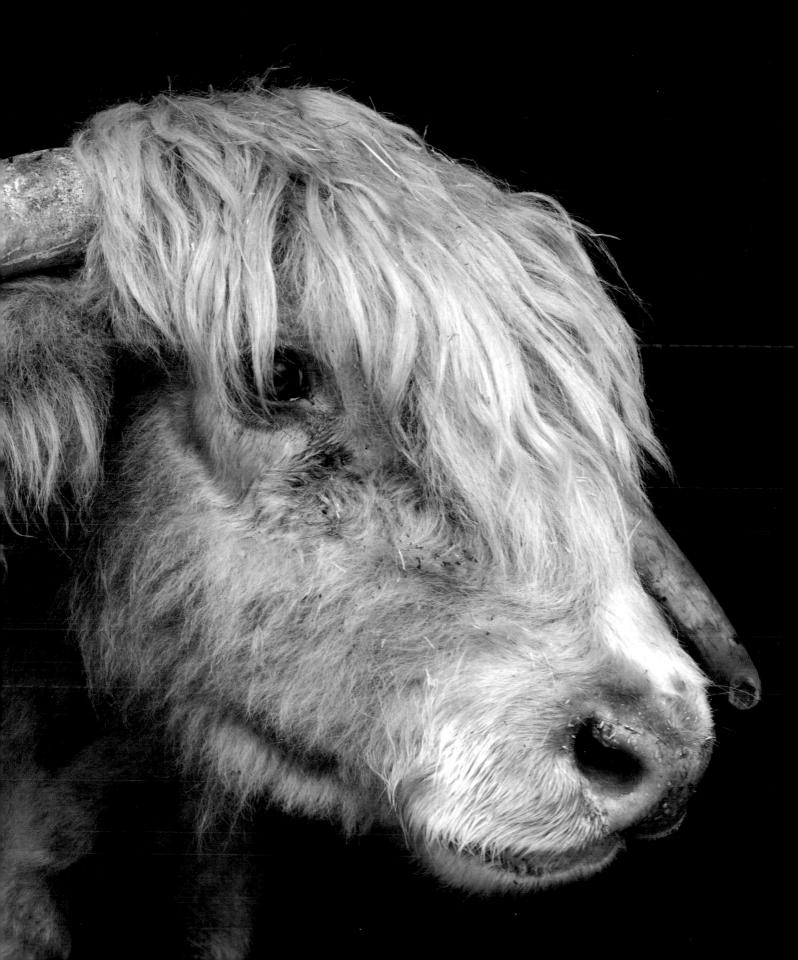

PENNY

BOER GOAT

..

Boer goats originated in South Africa and are used for meat production.
Their name derives from the Afrikaans word for farmer, boer. Boer
goats have an inquisitive, docile temperament. Because of their intelli-
gence and floppy ears, they are often described as doglike. Boers are
prized for being exceptionally attentive mothers.

Penny is affectionate and charming. When people call her name, she
answers and comes trotting over. Her best friend is another goat named
Gus. Penny likes to follow her "mom" around while she is cleaning the
barn, looking over her shoulder and inspecting her work.

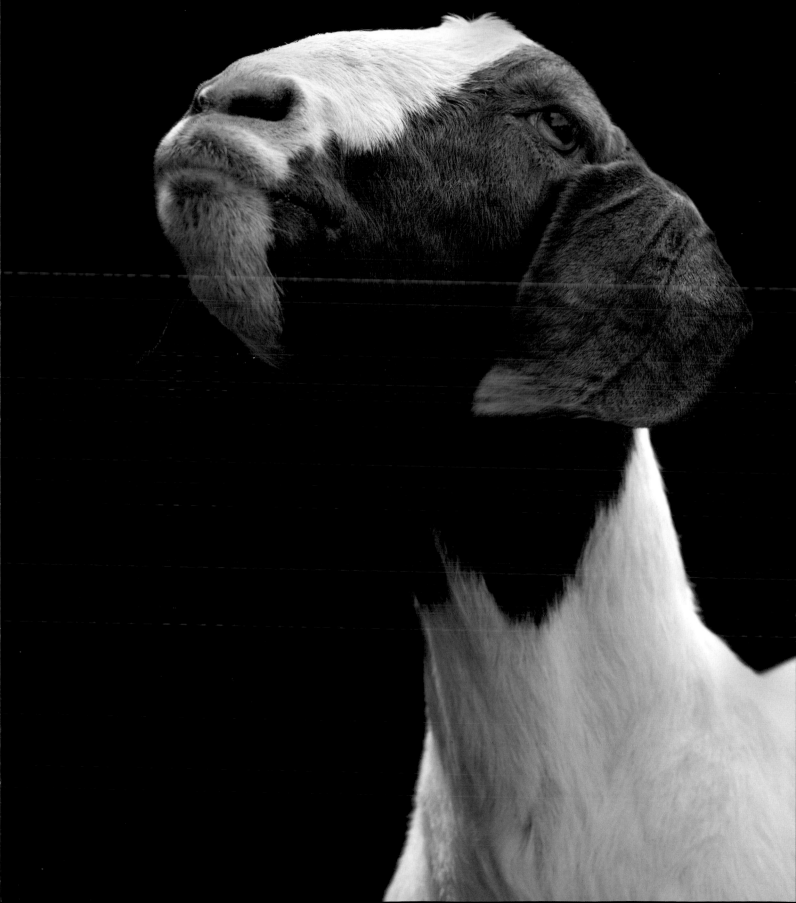

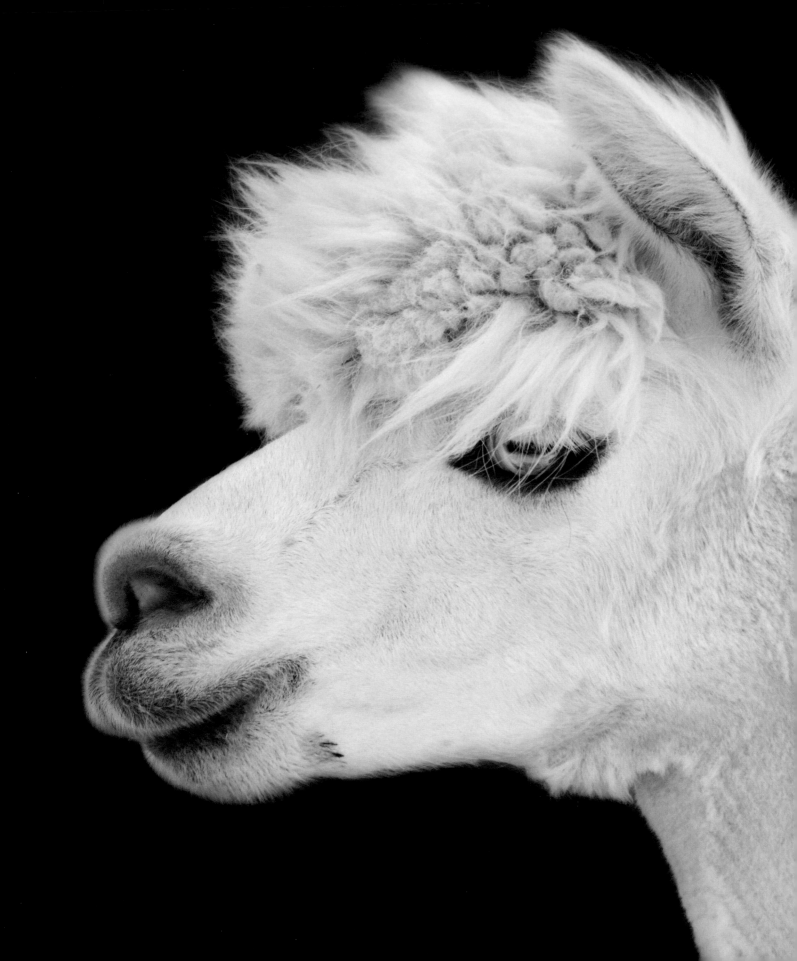

LOLA

HUACAYA ALPACA

Alpaca fiber is waterproof, flame resistant, and hypoallergenic. This remarkable fiber is often described as being stronger than mohair, finer than cashmere, smoother than silk, and softer than cotton.

Blindness occurs in about 80 percent of blue-eyed white alpacas. Lola was born blind but has no trouble navigating her grazing fields or finding friends. She has a rather distinctive do that, combined with her blue eyes, makes her a stylish favorite with visitors.

PERCY

INDIAN PEAFOWL

. .

Peacocks are large, brightly colored pheasants with distinctive tail feathers that can occupy up to 60 percent of their body length. Only the male of the species has the characteristic long train of iridescent blue and green feathers. This elaborate display of feathers is used to attract a mate. Although the term *peacock* is commonly used to refer to birds of both genders, technically only males are peacocks, with females being peahens. Peafowl are among the largest flying birds in the world.

Percy was seized in a large and well-publicized cruelty investigation that involved hundreds of animals. At the sanctuary, he is the shyest and sweetest of the peacocks and often likes to stay inside on his perch when the others are outside running around. He is very vocal and can often be heard honking and beeping or making other peacock noises when he hears sirens or power tools.

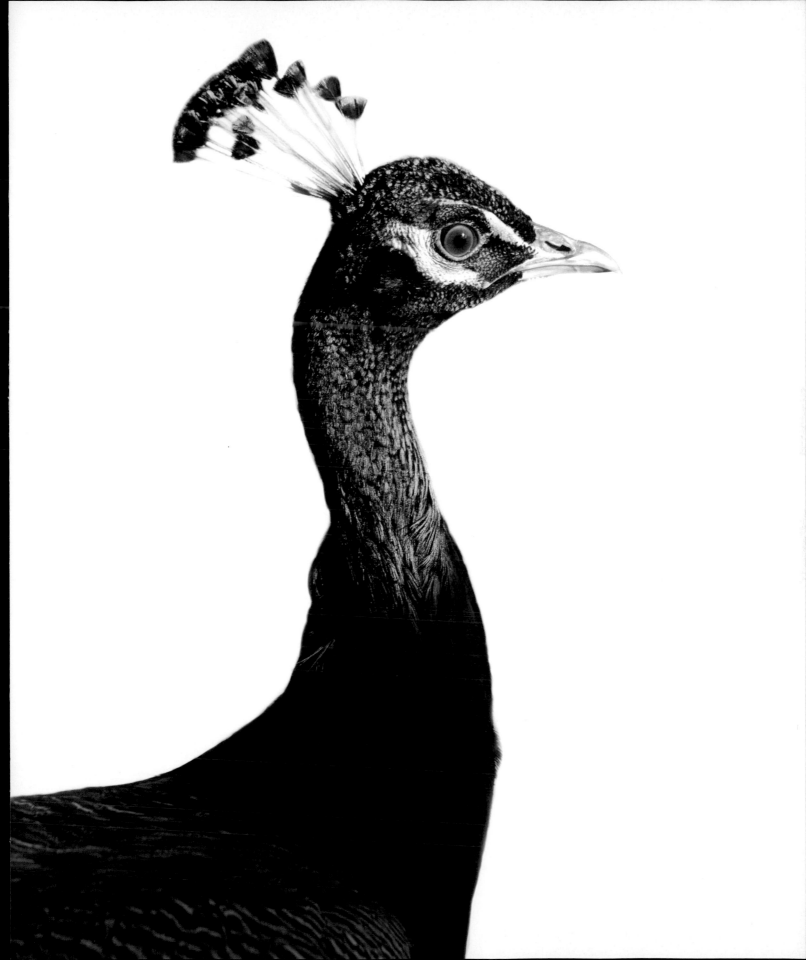

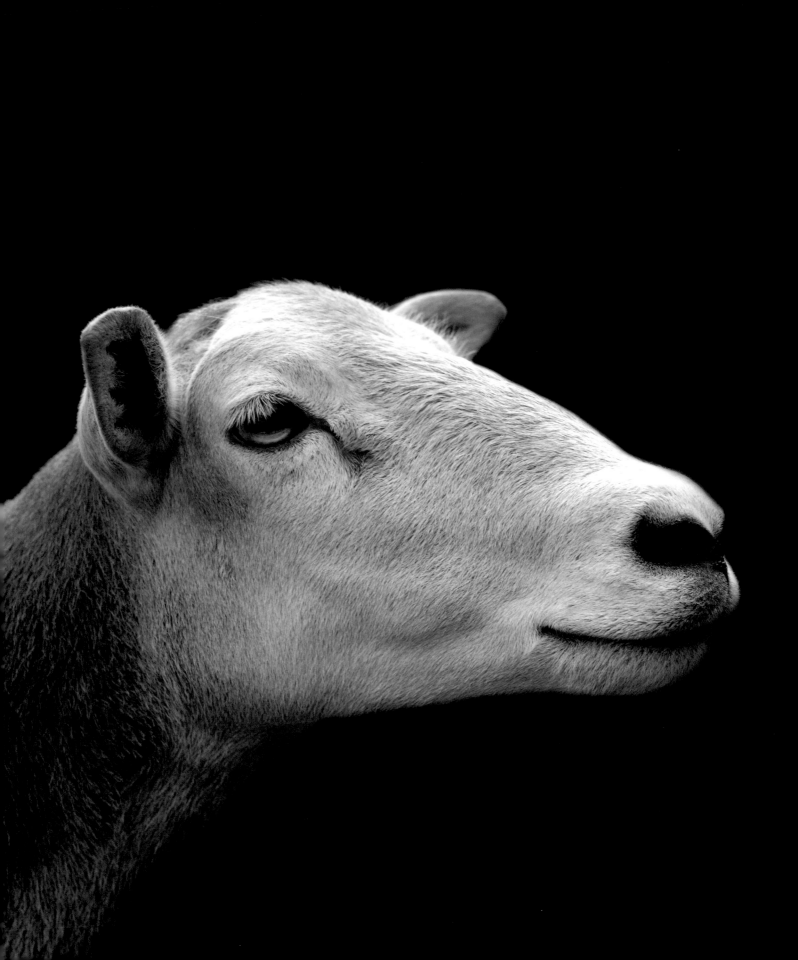

CAGNEY

KATAHDIN MIX SHEEP

Katahdin sheep have "hair" instead of wool and therefore do not require shearing. Hair sheep are raised solely for meat. The breed is desirable because these sheep are hardy and low maintenance.

Cagney lives with her mom and sister, and the three sheep are inseparable. Cagney's parents were originally purchased to be raised for food, but the owners could not bring themselves to kill them, so Cagney and her offspring became unwanted pets (the father passed away of old age). Eventually they were given to a small farm/sanctuary nearby, which could better care for them.

GERTRUDE

BRAHMA CHICKEN

..

Brahmas are large, stately chickens, often called the "king of all poultry."
Roosters can weigh twelve pounds or more, while hens average about ten
pounds each. The origin of this handsome chicken is much debated, but
it is generally agreed upon that this breed was developed in the United
States from several large-breed chickens imported from Shanghai, China.
Despite their size and strength, Brahma chickens tend to have a friendly
disposition, with notable personalities.

Gertrude is very social and quite vocal; she likes to talk when she hangs
around with her human pals. Some days she lets them pet her, and other
days she just wants to chat and eat seed from their hands.

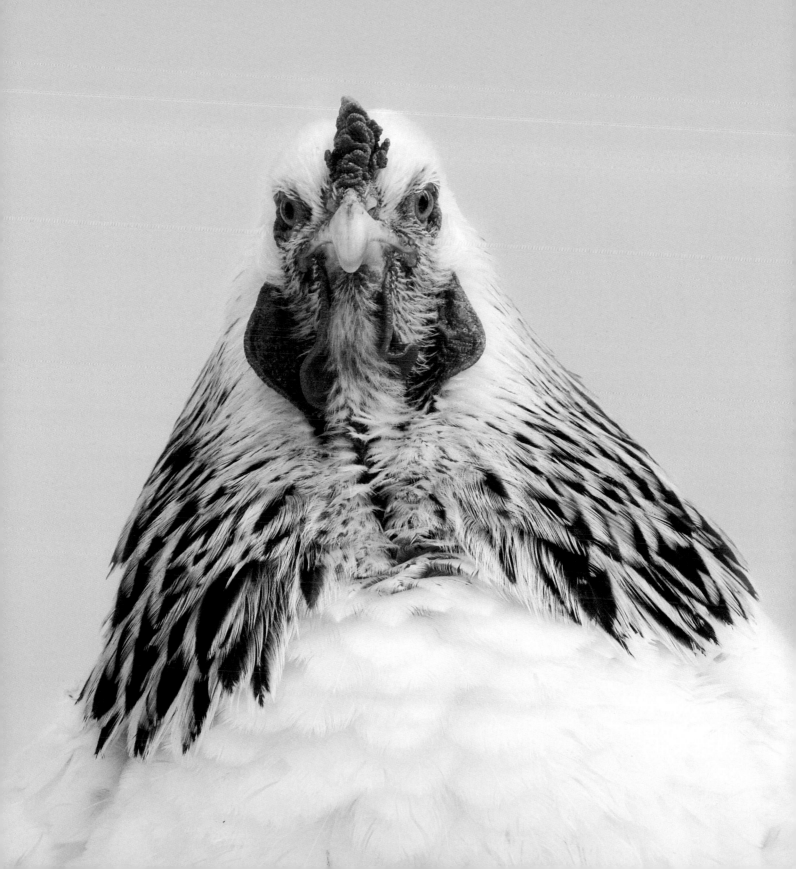

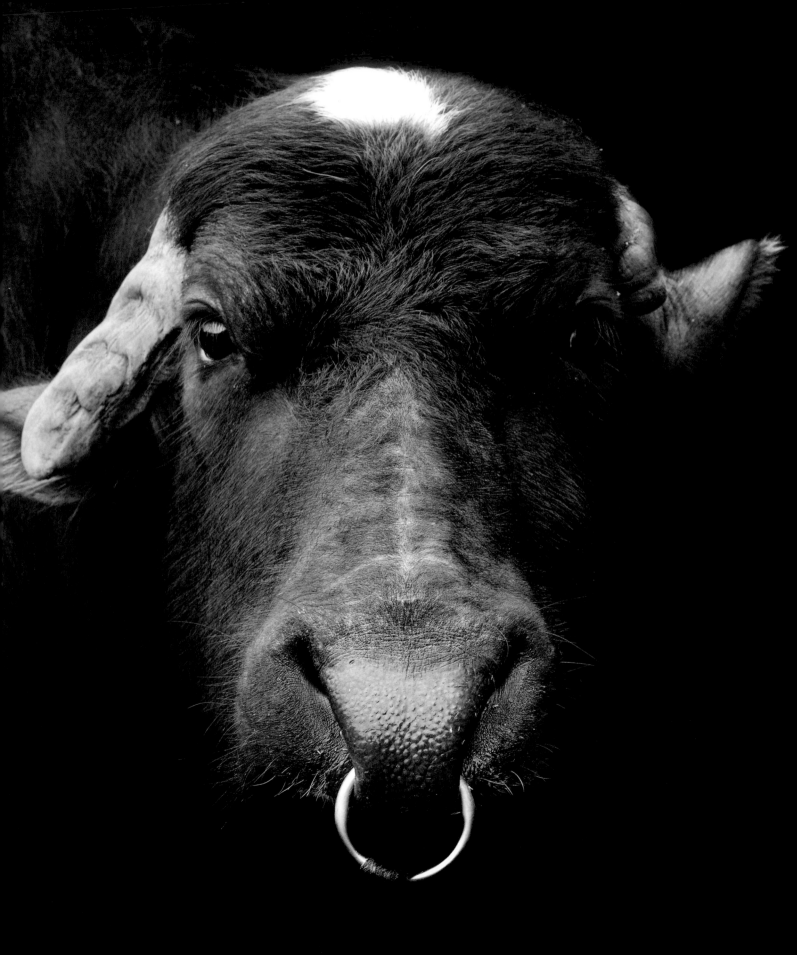

BUFFALO BILL

WATER BUFFALO

. .

Water buffalo are farmed primarily for their milk, which is used
to make the eponymous buffalo mozzarella; however, many are also
used for meat.

Buffalo Bill was born on a water buffalo farm in upstate New York.
As an infant, he was given to a small, family-owned farm in
Massachusetts, to be raised as a meat product. However, after months
of nursing baby Bill, the family fell in love with this affectionate, gentle
buffalo. By the time Bill was a healthy young adult, the family had
decided to keep him as a pet, even after he reached his adult weight of
over a ton. In watching Bill's gentle way with the family's children,
the farmers thought that perhaps he would be a soothing, therapeutic
presence for children with autism, so Bill started down the road
of becoming perhaps the world's first "therapy buffalo." His favorite
activities are eating grass and snuggling with the family's youngest
daughter.

LEXI

BERKSHIRE PIG

··

Legend has it that Berkshire pigs were discovered by Oliver
Cromwell's army over three hundred years ago in Reading,
England (county of Berkshire). The Berkshire was first brought
to the United States in 1823 and today is considered a rare breed.

Lexi was the runt of a litter born on a farm that raised animals
for farm-to-table restaurants. A culinary intern at the farm
convinced the owners to give Lexi to him, and he then brought
her to a sanctuary, where she thrived. Lexi made up for
starting life as a runt: these days she is ten times the size she
was when she first arrived and has a healthy attitude to match.
She is said to be the sassiest, most curious pig on the farm.
She and her best buddy, Cici, spend the days rooting and
soaking in mud puddles.

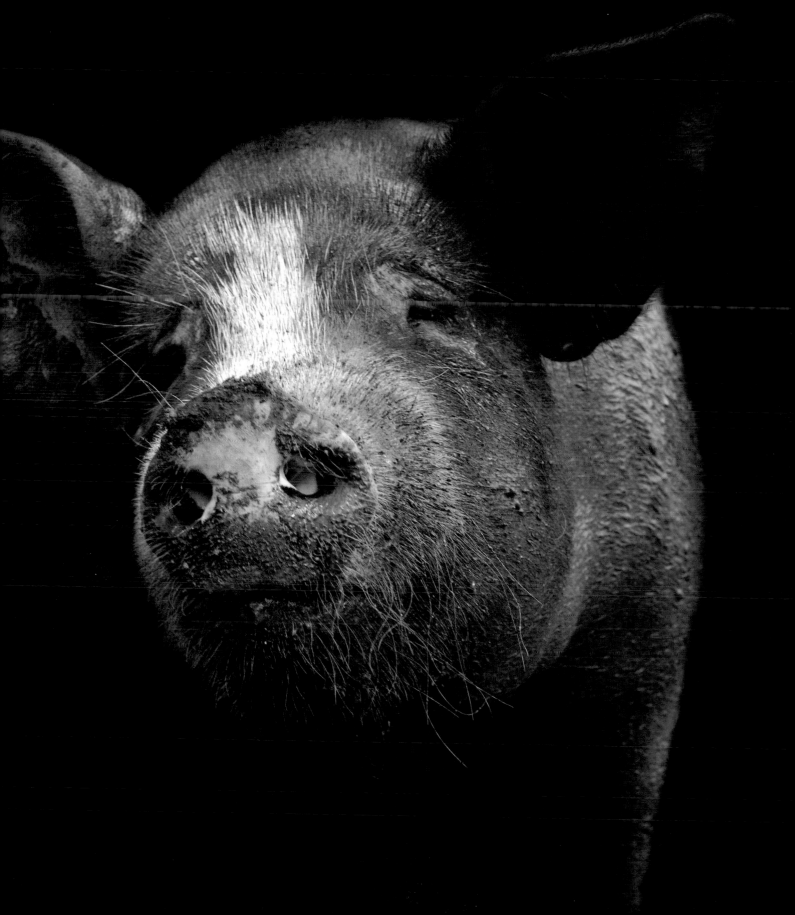

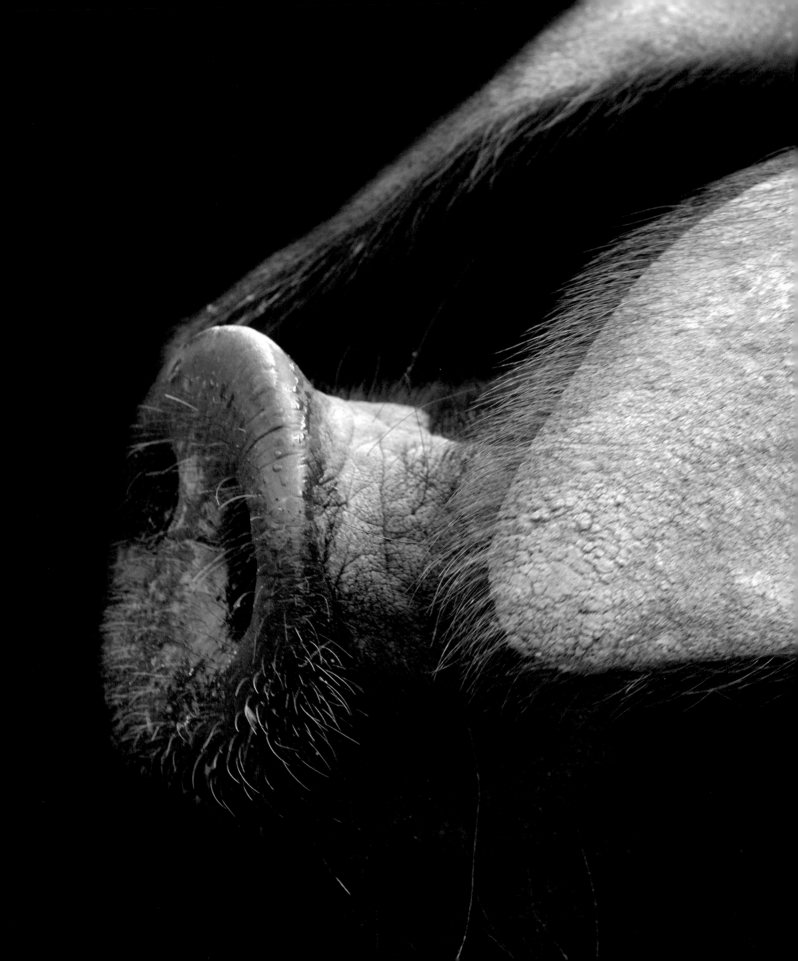

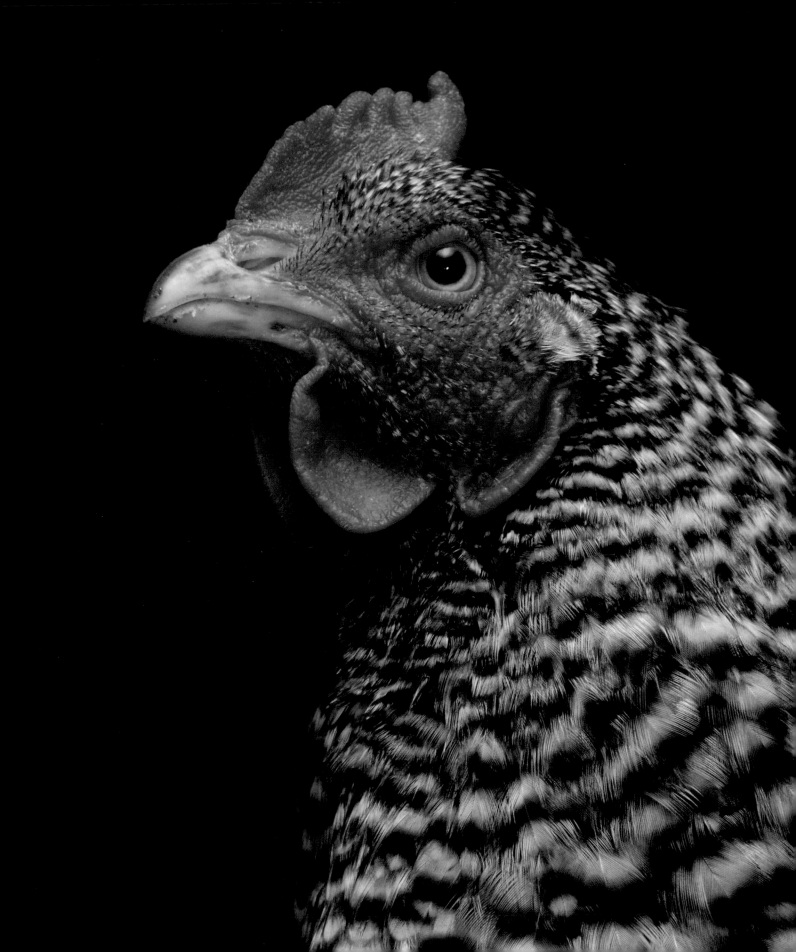

IRENE

PLYMOUTH ROCK CHICKEN

The Plymouth Rock chicken, also called a Barred Rock, was first exhibited as a breed in Massachusetts in the mid-nineteenth century. It was the most popular breed of chicken in the United States for more than fifty years. Plymouth Rock hens are known for being friendly and mild-tempered.

Irene was half of a sister duo of Plymouth Rock hens, and the two were inseparable until Irene's passing of old age in 2016. Her sister, Iris, lives on, though she is quite elderly now.

BEAN

NIGERIAN DWARF GOAT

· ·

Nigerian Dwarf goats originated in West Africa but were transported around the world on ships as food for exotic animals who had been captured and were being brought to zoos. Goats who survived the trip were kept and cultivated in herds at the zoos. In modern times, they are generally kept as family milk goats and pets.

Bean's mother was a milk goat on a small family farm when she gave birth to two male kids. The inexperienced mom rejected them both at birth. Bean's brother did not survive, but Bean was taken in by a young woman who bottle-fed him and then brought him to a sanctuary, where he roams free and greets visitors with much vigor. Bean is very tactile and can often be seen trying to nibble on whatever is around: tables, clothes, and even camera bags. At night, Bean sleeps at the foot of his human mom's bed.

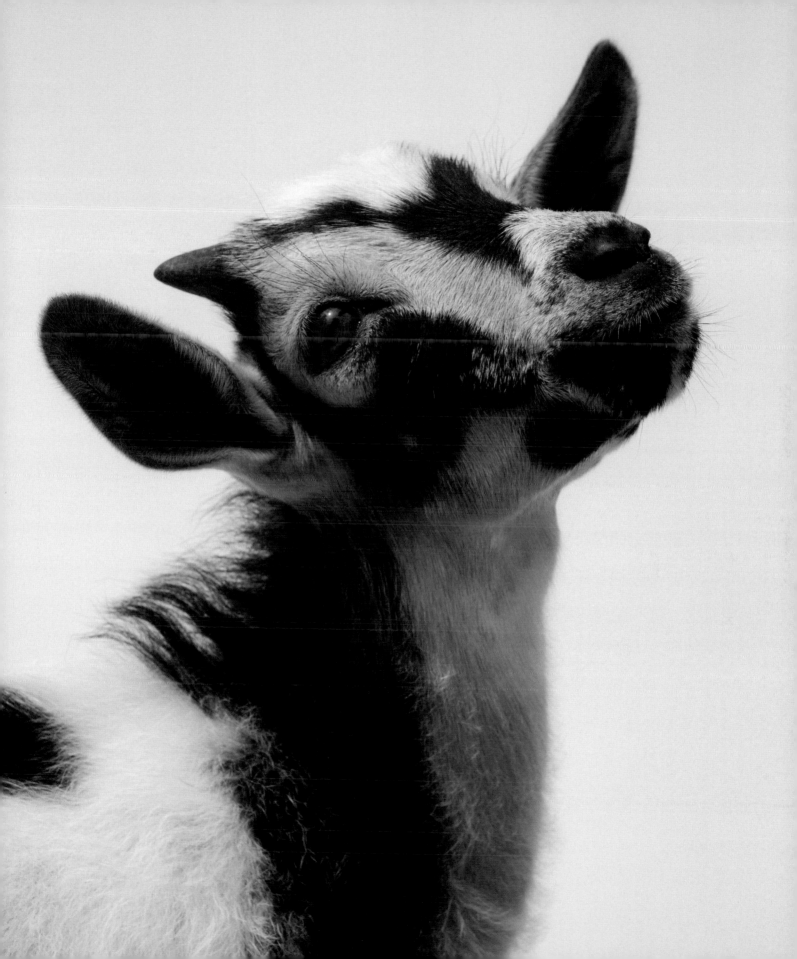

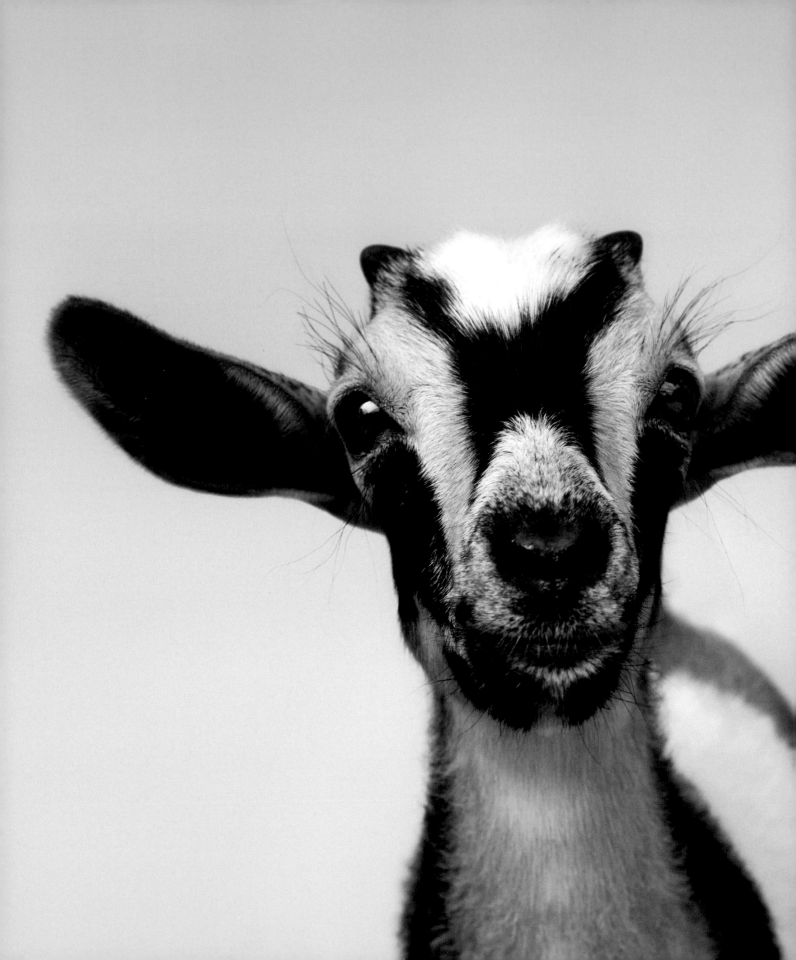

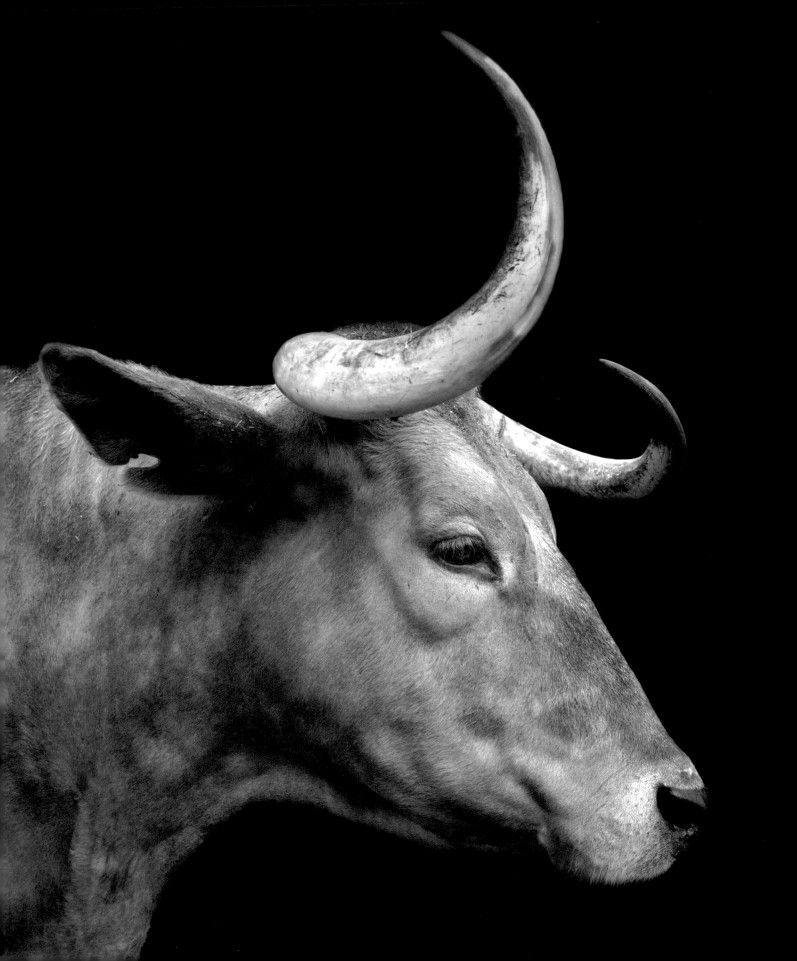

ISAAC

TEXAS LONGHORN COW

· ·

Known for their characteristic horns, Texas Longhorn cattle are
among the most iconic of all livestock. The breed is descended from
the very first cattle brought to America by Columbus and the Spanish
colonists over five hundred years ago. As such, they are uniquely
American, the only breed of cattle that has developed through natural
selection in America. Longhorns are drought-resistant and can survive
on poor, scrubby vegetation.

Isaac was seized from an unethical sanctuary along with dozens
of other animals who were severely neglected and malnourished.
He had never lived in isolation, so he was afraid of other cattle when
he arrived at his new home. Despite being socialized with cattle,
he ended up feeling more comfortable around goats, and he now lives
with his best friends, three goats named Maxie, Ingrid, and Marilyn.

DOLLY

WOOLLY LLAMA

...

Llamas are natural protectors and are often used as livestock guardians. Always watchful and alert, they will sound an alarm, walk or run toward an intruder, or even chase or kick it. While sheep or goats tend to be afraid of big dogs like Great Pyrenees that also guard livestock, they usually willingly accept llamas into their flock. Llamas are very social and enjoy the company of other animals.

Dolly watches over a flock of sheep at her sanctuary and warns them of any predators or danger.

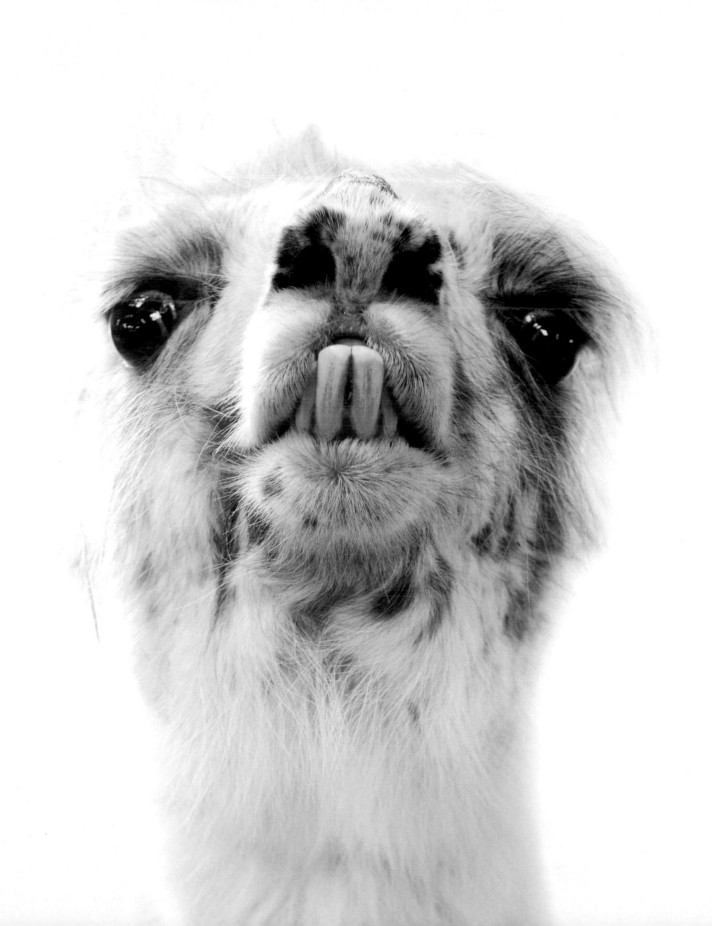

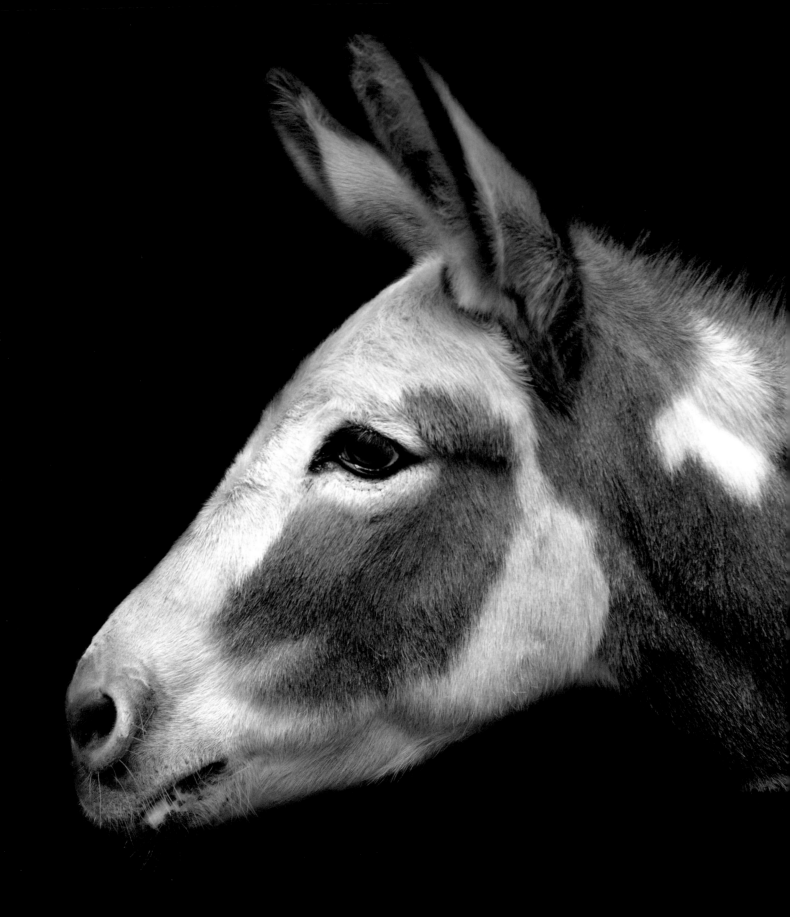

BIANCA

SICILIAN MINIATURE DONKEY

Miniature donkeys are always fewer than thirty-six inches high at the shoulder. Sicilian donkeys have a dark mane that extends down their back into a stripe and another stripe across their shoulders, which together form the shape of a cross. They are often called the Holy Cross donkey. According to myth, Jesus rode into Jerusalem on Palm Sunday on a rescued Sicilian miniature donkey. After Jesus was crucified, the donkey was immensely grieved, for he felt he should have been the one to carry the weight of the cross. He turned away from the sight of the cross, but he would not leave his master's side. It was then that the shadow of the cross fell upon the donkey's back and was left there by the Lord as a visible reminder that all love, no matter how humble, has its rewards.

Bianca's devotion paid off when she and two other donkeys were brought to a sanctuary after a loving owner could no longer care for them. Bianca loves her donkey friends and enjoys running through the woods and getting her ears scratched by visitors and caretakers.

CECELIA

HOLLAND MIDGET WHITE TURKEY

· ·

The Midget White turkey is a miniature version of the Broad-Breasted White turkey, which is the most common breed used in industrial farming. Midget Whites are the smallest standard variety of turkey and weigh only a little more than the largest chicken.

Cecelia was rescued from a factory farm, where she had been debeaked. The beaks of poultry are routinely "trimmed" in factory farms to prevent the birds from injuring themselves and other birds by engaging in stress-induced behaviors like feather plucking and pecking. Cecelia is the smallest of the turkey group at the sanctuary. Her best friend is another turkey called Anna.

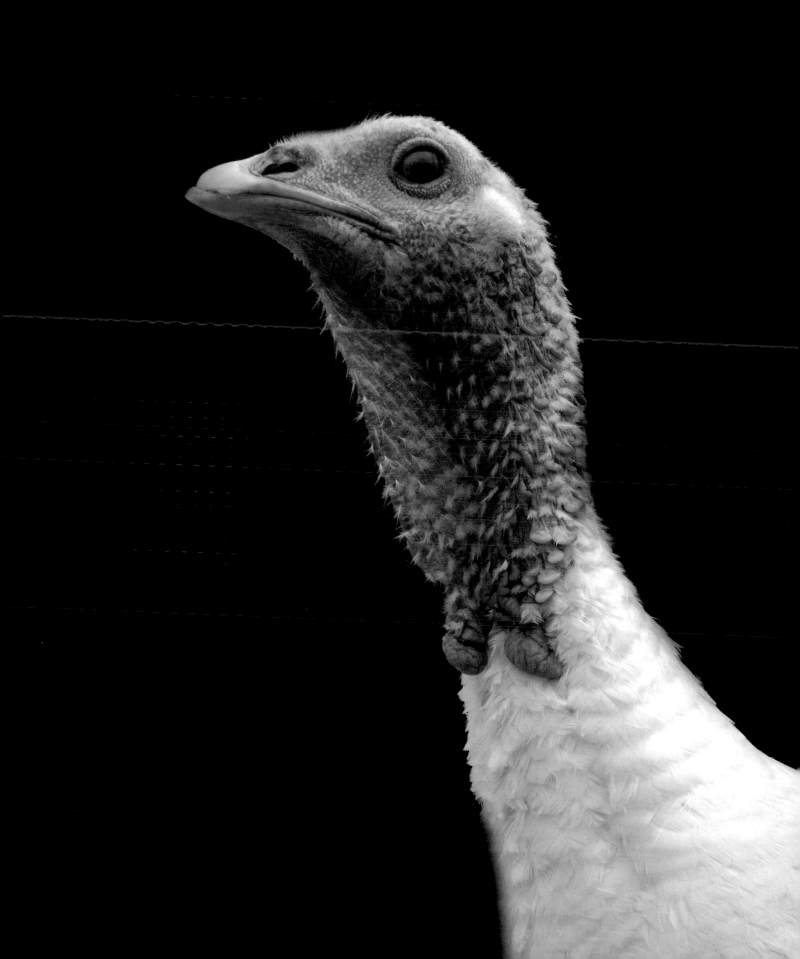

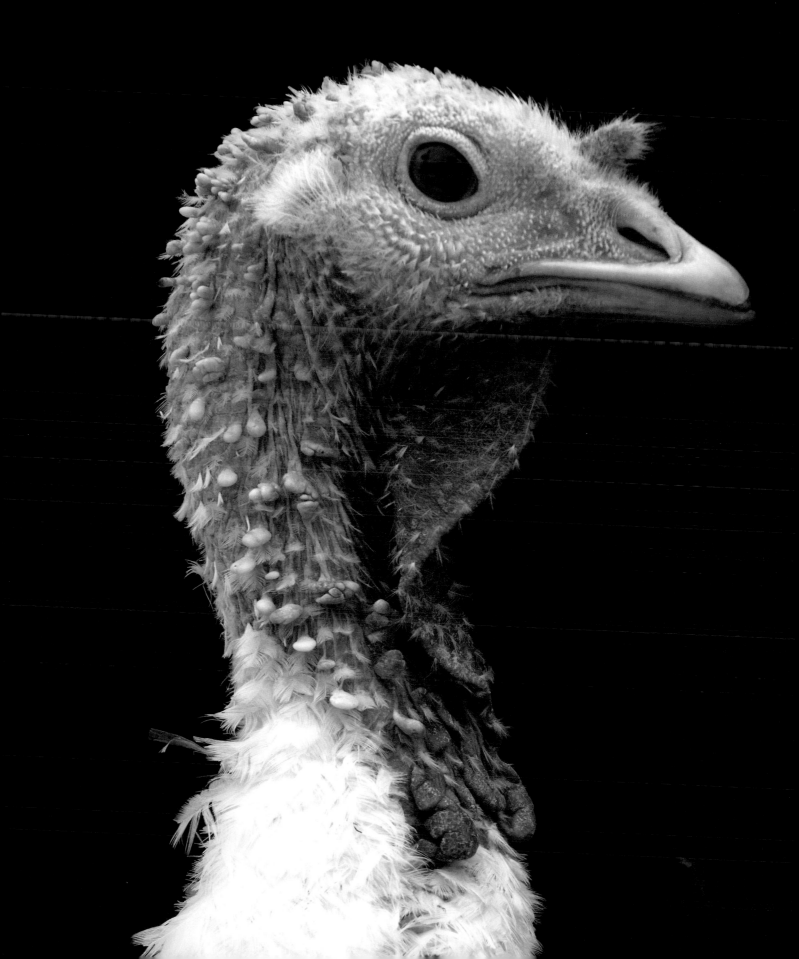

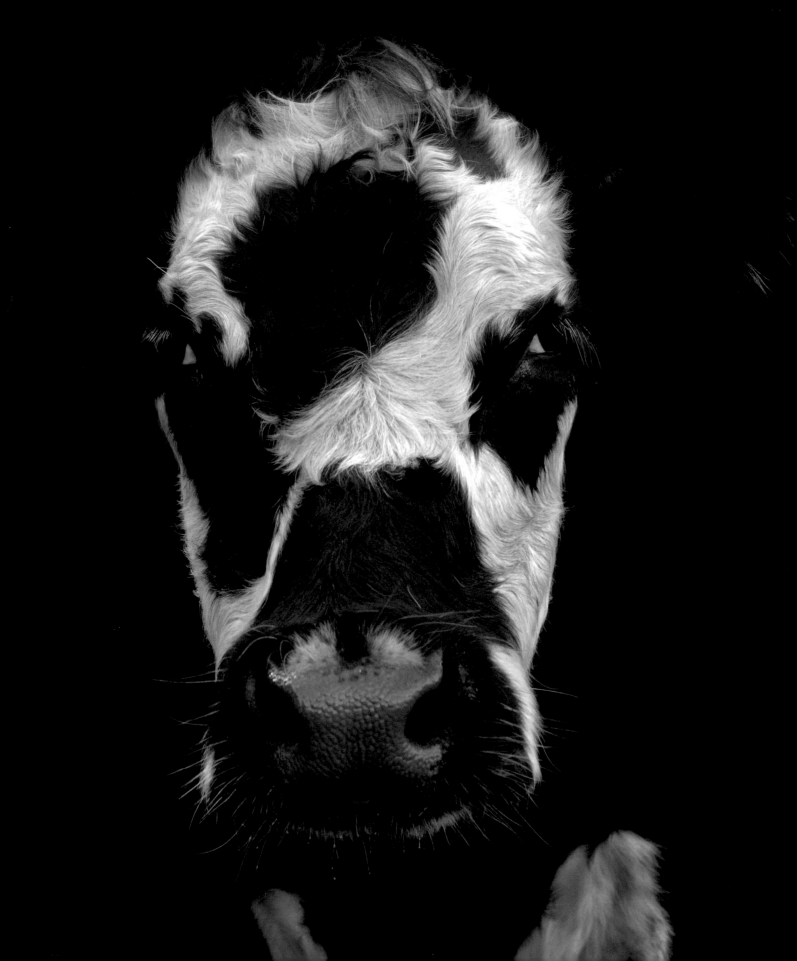

BENJAMIN

BLACK BALDY COW

Black Baldy cows are a cross between red-and-white Hereford cattle and a solid black breed like Black Angus. They are used for meat production. Black Baldy cattle, like any crossbreed, are desirable because they tend to exhibit "hybrid vigor," the increased health and vitality often inherent to mixed-breed animals.

Benjamin came from a beef farmer who had a change of heart and decided to stop farming. He wanted to find homes for all of his remaining cattle and brought Benjamin to a sanctuary. The sanctuary owner says that Benjamin tries to pretend he's brave, but his tough facade will crumble at ear-cleaning time or at the introduction of new toys or equipment. He loves to groom his bovine family and roughhouse with his sister, Blossom, and can be quite mischievous, as he often tries to steal treats set out for his elderly pasturemate.

CHUCKY

ALPINE CROSS GOAT

..

Alpine goats are a breed of domestic dairy goat that originated in the French Alps. They have excellent balance and agility. Alpine goats can traverse rocky terrain, scale mountains, and even climb trees.

Chucky was very fearful when rescued. To make matters worse, since he is a fainting goat, he kept collapsing every time he was frightened. However, he became fast friends with another new arrival, a goat named Benedict, who needed daily treatments from human caregivers. Thanks to this subtle daily socialization, Chucky slowly began to trust and like people. He is now very friendly and loves posing for photographs.

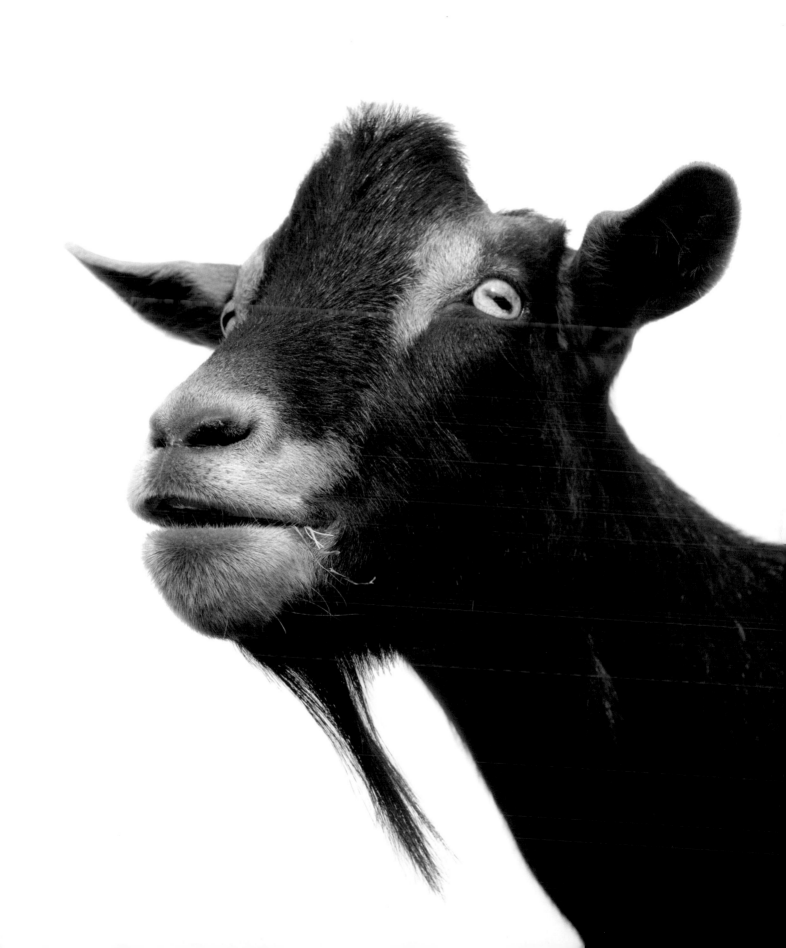

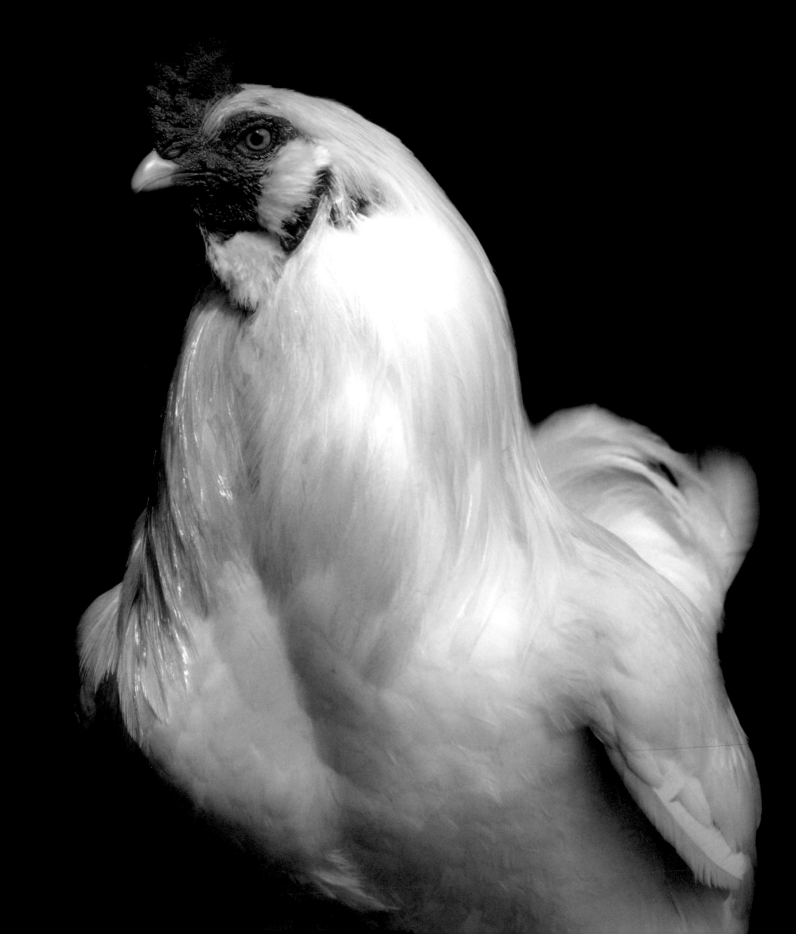

COSMO

AMERAUCANA /

RED STAR CROSS ROOSTER

..

Roosters are male chickens with internal clocks that allow them to anticipate daylight. This is why the rooster always seems to crow right before dawn. In a flock with several roosters, only the highest-ranking rooster has the authority to "break dawn."

Cosmo is three years old and the head of a flock. He is the first to officially wake everyone in the morning and likes to crow back and forth with another rooster down the block throughout the day.

JUSTICE

DOMESTIC YAK

..

Yaks are thought to be related to cows but allegedly diverged from cattle between one and five million years ago; they may be more closely related to bison, which occupy a different genus and resemble them more in appearance. Yaks are generally found in very high altitudes of 14,000 to 20,000 feet, where they are well adapted to thrive. Yaks have larger hearts and lungs than cattle who live at lower altitudes, as well as a better capacity for transporting oxygen through the blood, which makes them ideal for places like Tibet, Mongolia, China, and Nepal.

After being rejected by his mother, Justice was hand raised on a hobby farm in Massachusetts. Despite having lots of space and wonderful care, as he grew bigger and bolder, Justice began escaping regularly from the farm. He would go out on "joyrides" around town and get into trouble with the neighbors. Eventually, after many such occasions, the town said that he had to go. Justice was subsequently taken in by friends who owned another hobby farm on Block Island. Although his behavior proved challenging over the years, his charm won out. These days, Justice has slowed down a bit and is now quite content to stand by the fence and beg food from visitors. He opens his mouth extremely wide (as pictured) to receive the pellets. Justice's middle name is said to be "Wanderlust."

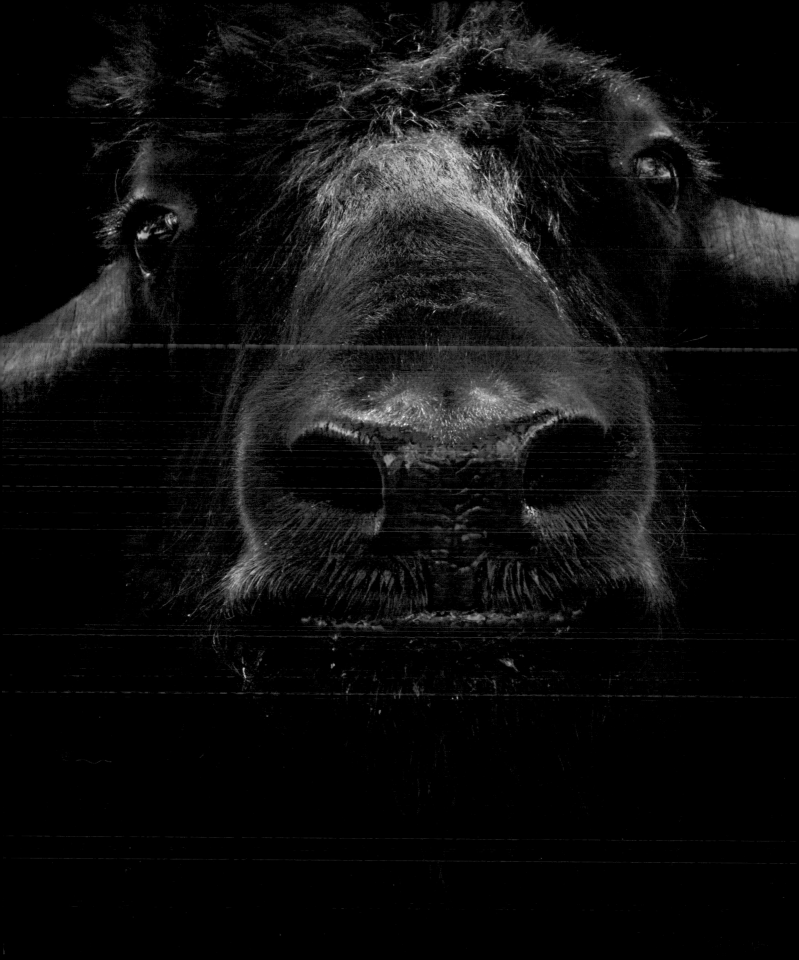

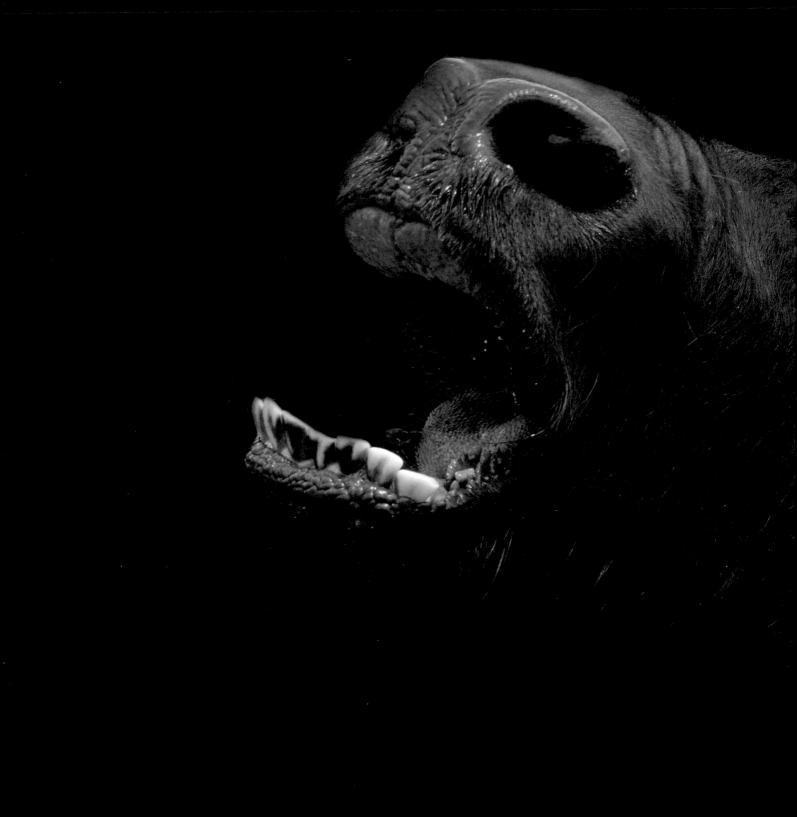

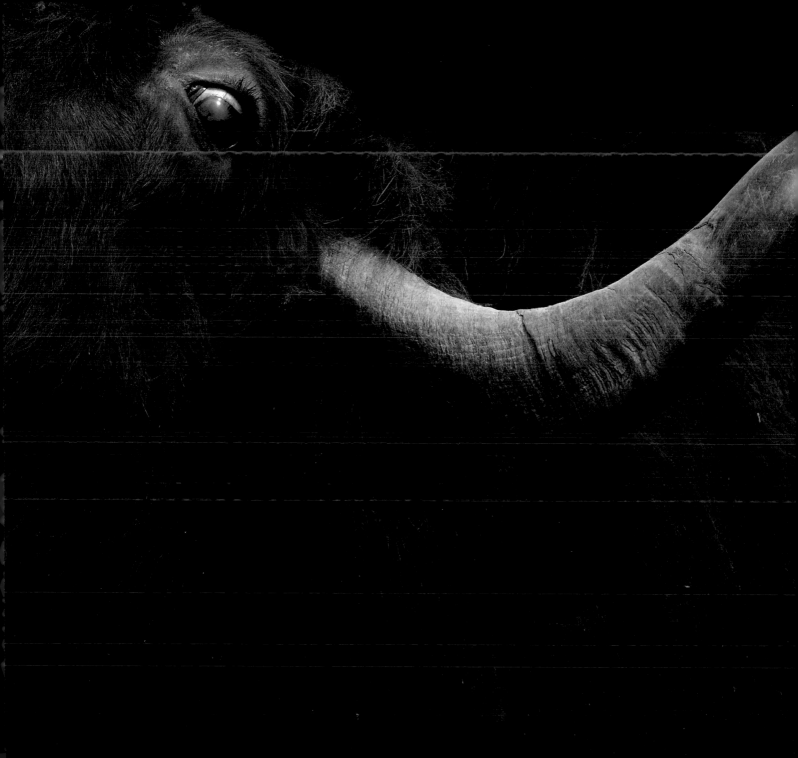

ACKNOWLEDGMENTS

A heartfelt thank-you to all of the sanctuaries who welcomed me and showed me the love that lives in their hearts as well as in their pastures, barns, and paddocks: Luke Hess, Susie Coston, and everyone at Farm Sanctuary Watkins Glen; Kathy Stevens, Catskill Animal Sanctuary, and the staff at the Homestead; Debra White, Jill Pierce, and Dan Fiske at Winslow Farm Sanctuary; Lindsey Audunson, Carrie Hawthorne, and Buttonwoods Zoo; Jane Deming and the 1661 Farm; Wendy Taylor and West Place Animal Sanctuary; Renee Rogers, Anne Peterson; Ashley Nester and Woodstock Farm Sanctuary; Shana Cobin; Maple Farm Sanctuary.

As always, my work is made visible through the dedication of my friend and agent of over a decade, Joan Brookbank, along with my Princeton Architectural family: Sara Stemen, my patient and articulate editor who always has the right words; publisher Kevin Lippert; editorial director Jennifer Lippert; design director Paul Wagner, who brought *Radiant* to life on the pages with his brilliant, colorful design; production director Janet Behning; prepress coordinator Valerie Kamen; sales and marketing director Lia Hunt; and publicist Wes Seeley.

FARM SANCTUARIES

This list is intended as a reference. Sanctuaries whose animals are featured in this book are starred ().*

ARIZONA

Ironwood Pig Sanctuary | Tuscon
WWW.IRONWOODPIGSANCTUARY.ORG

Whisper's Sanctuary | Sierra Vista
WWW.RRHEARTRANCH.COM

CALIFORNIA

Animal Place Rescuc Ranch | Grass Valley
ANIMALPLACE.ORG/RESCUE-RANCH

Farm Sanctuary | Acton, Southern California
WWW.FARMSANCTUARY.ORG/THE-SANCTUARIES/
LOS-ANGELES-CA

Farm Sanctuary | Orland, Northern California
WWW.FARMSANCTUARY.ORG/THE-SANCTUARIES/
ORLAND-CA

Flip Side Sanctuary | Sebastapol
WWW.FLIPSIDESANCTUARY.ORG

The Gentle Barn | Santa Clarita
WWW.GENTLEBARN.ORG

Happy Hen Chicken Rescue | San Luis Obispo
WWW.CHICKENRESCUE.ORG

Harvest Home Animal Sanctuary | Stockton
HARVESTHOMESANCTUARY.ORG

PreetiRang Sanctuary | Dixon
WWW.PREETIRANGSANCTUARY.ORG

Sweet Farm | Half Moon Bay
WWW.SWEETFARM.ORG

COLORADO

Luvin Arms Animal Sanctuary | Erie
WWW.LUVINARMS.ORG

Peaceful Prairie Sanctuary | Deer Trail
WWW.PEACEFULPRAIRIE.ORG

FLORIDA

Kindred Spirits Sanctuary | Ocala
WWW.KSSFL.ORG

Rooterville | Melrose
ROOTERVILLE.ORG

GEORGIA

Full Circle Farm Sanctuary | Warm Springs
WWW.FULLCIRCLEFARMSANCTUARY.ORG

HAWAIʻI

Leilani Farm Sanctuary | Haiku
LEILANIFARMSANCTUARY.ORG

ILLINOIS

EARTH Sanctuary | Thawville
WWW.FACEBOOK.COM/EARTHANIMALSANCTUARY

Wedrose Acres | Gridley
WWW.WEDROSEACRES.ORG

INDIANA

Uplands Peak Sanctuary | Salem
UPLANDSPEAKSANCTUARY.ORG

IOWA

Iowa Farm Sanctuary | Marengo
WWW.IOWAFARMSANCTUARY.ORG

MAINE

Peace Ridge Sanctuary | Brooks
WWW.PEACERIDGESANCTUARY.ORG

MARYLAND

Poplar Spring Animal Sanctuary | Poolesville
WWW.ANIMALSANCTUARY.ORG

MASSACHUSETTS

✳ Maple Farm Sanctuary | Mendon
WWW.MAPLEFARMSANCTUARY.ORG

✳ Sunny Meadow Sanctuary | Holden
SUNNYMEADOWSANCTUARY.ORG

✳ Winslow Farm Animal Sanctuary | Norton
WWW.WINSLOWFARM.COM

MICHIGAN

Barn Sanctuary | Chelsea
WWW.BARNSANCTUARY.ORG

Sasha Farm | Manchester
WWW.SASHAFARM.ORG

MINNESOTA

Broken Roads Ranch | Eden Valley
WWW.BROKENROADSRANCH.ORG

Chicken Run Rescue | Minneapolis
WWW.CHICKENRUNRESCUE.ORG

Spring Farm Sanctuary | Long Lake
SPRINGFARMSANCTUARY.ORG

MISSOURI

The Gentle Barn | Dittmer
WWW.GENTLEBARN.ORG

NEW JERSEY

Rancho Relaxo | Salem County
WWW.RANCHORELAXONJ.ORG

Skylands Animal Sanctuary | Wantage
SKYLANDSSANCTUARY.ORG

Tamerlaine Farm | Montague
TAMERLAINEFARM.ORG

NEW MEXICO

Kindred Spirits Animal Sanctuary | Santa Fe
WWW.KINDREDSPIRITSNM.ORG

NEW YORK

✳ Catskill Animal Sanctuary | Saugerties
CASANCTUARY.ORG

✳ Farm Sanctuary | Watkins Glen
WWW.FARMSANCTUARY.ORG

Safe Haven Farm Sanctuary | Poughquag
SAFEHAVENFARMSANCTUARY.ORG

✳ Woodstock Farm Animal Sanctuary | High Falls
WOODSTOCKSANCTUARY.ORG

NORTH CAROLINA

Animal Haven of Asheville | Asheville
ANIMALHAVENOFASHEVILLE.ORG

Piedmont Farm Animal Refuge | Pittsboro
PIEDMONTREFUGE.ORG

Triangle Chicken Advocates | Chatham County
TRIANGLECHICKENADVOCATES.ORG

OHIO

Happy Trails Farm Animal Sanctuary | Ravenna
HAPPYTRAILSFARM.ORG

Sunrise Sanctuary | Marysville
WWW.SUNRISESANCTUARY.ORG

OREGON

Green Acres Farm Sanctuary | Silverton
GREENACRESFARMSANCTUARY.ORG

Lighthouse Farm Sanctuary | Scio
WWW.LIGHTHOUSEFARMSANCTUARY.ORG

Out to Pasture Sanctuary | Estacada
WWW.OUTTOPASTURESANCTUARY.ORG

Sanctuary One | Jacksonville
SANCTUARYONE.ORG

Wildwood Farm Sanctuary | Newberg
WILDWOODFARMSANCTUARY.ORG

PENNSYLVANIA

Chenoa Manor | Avondale
WWW.CHENOAMANOR.ORG

Farm Animal Rescue of Mifflinburg | Mifflinburg
WWW.FARMANIMALRESCUEOFMIFFLINBURG.ORG

RHODE ISLAND

✳ West Place Animal Sanctuary | Tiverton
WWW.WESTPLACE.ORG

TENNESSEE

The Gentle Barn | Knoxville
WWW.GENTLEBARN.ORG/TENNESSEE

The Pig Preserve | Jamestown
WWW.THEPIGPRESERVE.ORG

TEXAS

Black Beauty Ranch | Murchison
WWW.FUNDFORANIMALS.ORG/BLACKBEAUTY

Dreamtime Sanctuary | Elgin
WWW.DREAMTIMESANCTUARY.ORG

UTAH

Best Friends Animal Society | Kanab
BESTFRIENDS.ORG/SANCTUARY/VISIT-OUR-UTAH-
SANCTUARY

Ching Farm Animal Rescue & Sanctuary | Riverton
CHINGSANCTUARY.ORG

VERMONT

Gerda's Equine Rescue | Townshend
GERDASEQUINERESCUE.ORG

Vine Sanctuary | Springfield
VINE.BRAVEBIRDS.ORG

VIRGINIA

Peaceful Fields Sanctuary | Winchester
PEACEFULFIELDSSANCTUARY.ORG

Rikki's Refuge | Orange County
RIKKISREFUGE.ORG

WASHINGTON

BaaHaus Animal Rescue Group | Vashon
WWW.BAAHAUS.ORG

Pasado's Safe Haven | Sultan
WWW.PASADOSAFEHAVEN.ORG

Pigs Peace Sanctuary | Stanwood
WWW.PIGSPEACE.ORG

Precious Life Animal Sanctuary | Edmonds
WWW.PRECIOUSLIFEANIMALSANCTUARY.ORG

River's Wish Animal Sanctuary | Spokane County
WWW.RIVERSWISHANIMALSANCTUARY.ORG

WEST VIRGINIA

Pigs Animal Sanctuary | Shepherdstown
PIGS.ORG

WISCONSIN

Autumn Farm Sanctuary | Cedarburg
WWW.AUTUMNFARMSANCTUARY.COM

Heartland Farm Sanctuary | Madison
HEARTLANDFARMSANCTUARY.ORG

Soul Space Farm Sanctuary | New Richmond
WWW.SOULSPACESANCTUARY.ORG

PUBLISHED BY:
Princeton Architectural Press
A McEvoy Group company
202 Warren Street, Hudson, NY 12534
Visit our website at www.papress.com

Princeton Architectural Press is a leading publisher in architecture, design,
photography, landscape, and visual culture. We create fine books and stationery
of unsurpassed quality and production values. With more than one thousand titles
published, we find design everywhere and in the most unlikely places.

EDITOR: Sara Stemen
DESIGNER: Paul Wagner

SPECIAL THANKS TO: Paula Baver, Janet Behning, Abby Bussel, Benjamin English,
Jan Cigliano Hartman, Susan Hershberg, Kristen Hewitt, Lia Hunt, Valerie Kamen,
Jennifer Lippert, Sara McKay, Parker Menzimer, Eliana Miller, Nina Pick, Wes Seeley,
Rob Shaeffer, Marisa Tesoro, and Joseph Weston of Princeton Architectural Press
—Kevin C. Lippert, publisher

Library of Congress Cataloging-in-Publication Data
Names: Scott, Traer, author.
Title: Radiant : farm animals up close and personal / Traer Scott.
Description: First edition. | New York : Princeton Architectural Press, [2018]
Identifiers: LCCN 2018007248 | ISBN 9781616897154 (hardcover : alk. paper)
Subjects: LCSH: Domestic animals—Pictorial works. | Photography of livestock.
Classification: LCC SF76 .S36 2018 | DDC 636—dc23
LC record available at https://lccn.loc.gov/2018007248